neon nevada

neon nevada

SHEILA SWAN AND PETER LAUFER

Foreword by Lili Lakich

Globe Pequot Press
Guilford, Connecticut

Interior design by Sheryl Kober
Map: Robert L. Prince © Morris Book Publishing, LLC

The Library of Congress has previously cataloged an earlier hardcover edition as follows:

Swan, Sheila
 Neon Nevada / Sheila Swan and Peter Laufer: foreword by Lili Lakich.
 p. cm.
 Includes bibliographical references (p.).
 ISBN 0-87417-245-4 (cloth : acid-free paper)
 ISBN 0-87417-246-2 (pbk.: acid-free paper)
 1. Neon Lighting–Nevada–History. 2. Electric signs–
Nevada–History. 3. Advertising, Outdoor–Nevada–History.
 I. Laufer, Peter. II. Title.
 NA4050.N44S9 1994
 659.13'6'09793–dc20
 93-23653

ISBN 978-0-7627-7068-7

Printed in China

10 9 8 7 6 5 4 3 2 1

For our photographer fathers,

Roy E. Swan and Thomas Laufer

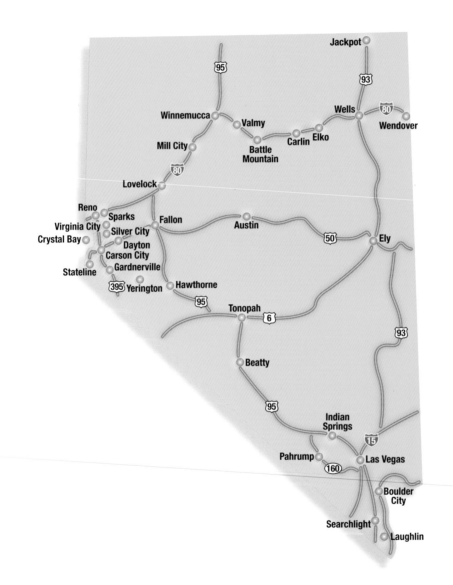

Contents

Foreword

Neon is associated with the highest aspirations of the American dream as well as the lowest manifestations of commercialism and banality. No other medium so aptly expresses the American spirit.

Although neon was developed for advertising in Paris during the early years of the twentieth century, nowhere did it become an integral part of the urban landscape and roadways as it has in the United States. Paris was called "the city of lights" before anyone saw Las Vegas or Reno. But Paris is moody and elegant with its mostly white incandescent lights, whereas Nevada cities and highways jump with lush, multicolored, glowing pictures.

It is not surprising that Americans had an immediate affinity for neon and created an abundance of spectacular pictorial signs. Since 1923, when the first neon sign in the United States lit up an automobile dealership in Los Angeles, neon has drawn us into movie palaces, casinos, roadside restaurants, and motels. Neon was the pre–World War II television: It could sell anything and did. Its luminous kinetic line made smoking, drinking, even girdles, glamorous. The boldness and brightness of neon stood out in the outsized landscape of the American West and suited our brash belief that anything is possible and opportunity awaits all.

The flip side of the character of a nation that plants its roots in the future is that it may also be careless with its past. With the development of plastics during World War II, the neon industry began to decline. Vacuum-formed plastic signs illuminated by fluorescent tubes could be produced cheaply and easily. As a result, new neon signs were not produced, old ones fell into disrepair, and many unique, well-designed landmarks were simply destroyed.

In the mid-1960s, when neon, at its nadir as an advertising medium, was associated with tawdry taverns and sleazy motels, it became attractive to artists seeking ways to incorporate elements of popular culture into fine art. My dissatisfaction with the traditional media that I studied in art school led me back to images that ignited my sense of wonder—the glowing, animated roadside signs of cowboys roping cattle, trucks with spinning wheels, and swan-diving women.

The Pioneer Club's glowing neon cowboy, which loomed over downtown Las Vegas for nearly half a century, pointed to himself with one hand and to the club below him with the other. He is our secular society's interpretation of the luminous painted images of the Christ pointing to himself with one hand and upwards to the heavens with the other.

Simon and Garfunkel's caustic song lyric "and the people bowed and prayed to the neon god they made" ironically points to the connection that neon has to religious iconography. The colored auras, the sinewy lines, the ability of the medium to depict imagery that glows from within—neon is a contemporary manifestation in the tradition of attempting to make icons and saints glow. Depicting subjects with halos around their heads, shimmering luminosity projecting from their bodies, or flames of fire enveloping their beings, artists have used these and other techniques in their struggle to portray the metaphysical. Neon makes the metaphor real.

This iconoclastic relation between neon and religious experience has not been lost on the contemporary artists who work in neon sculpture. Most of them were drawn to the medium because of its alluring references to the magical, the metaphysical, the spiritual. They are our modern-day alchemists, transforming a material that has been stigmatized by a wrong-side-of-the-tracks reputation into vibrant artworks of radiant and jewel-like beauty.

For many of these artists, their initial inspirations were the neon signs of the American landscape. By taking neon out of the context of advertising and using it as an expressive medium, artists have called attention to the diverse ways in which neon can be employed. Such has been their contribution to the renaissance neon is now enjoying after coming close to extinction in the 1960s and 1970s.

In 1981 I founded the Museum of Neon Art (MONA) in Los Angeles with a dual mission: to document and preserve outstanding examples of neon signs and to exhibit contemporary fine art in electric media. MONA fosters appreciation of the electric arts and art history through its classes in neon design and techniques and its guided tours of Los Angeles's old and new neon signs and fine art installations. In addition to its regular exhibition schedule, the museum sponsors traveling exhibitions and curates exhibitions for other museums, galleries, and art centers throughout the United States.

As artifacts of American culture, neon signs illuminate our character and our history. *Neon Nevada* documents the splendid variety of neon that has been produced, maintained, and destroyed in one state where neon signs have enjoyed uninterrupted reign. The work of Sheila Swan and Peter Laufer is a welcome addition to a widely recognized but scarcely recorded history.

Lili Lakich
Founding Director
Museum of Neon Art
Los Angeles

Electric Jewels of the Nevada Desert

In the early 1970s, we had two neon signs glowing in our Silver City, Nevada, living room. One was a red heart. Next to it, in flowing script, was the bright pink word *Neon.*

For us, the two signs quickly became part of our lives. We turned them on evenings and watched them flicker and buzz, the deep red of the heart and the salmon pink of the neon. The tubes cast fluid reflections on the windows, and we found that the signs—for us—were alluring and exciting. Our eyes were drawn to them. They attracted our attention and, much like a fireplace, created a warm focal point in our old mining camp home.

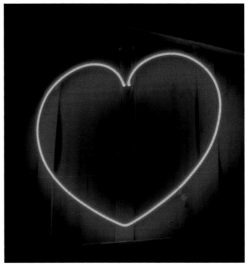

The authors' neon heart, 1993.

Even unlit, the signs dominated the room. Friends came to visit us and would look first to the heart and then to neon.

"Would you turn those on?" They would always ask to see the tubes shine. "I've never seen a neon sign in a home before," they would say. "How do they work?"

And, invariably, the reactions were intense and immediate. The moving neon light hit them and they either loved it or they hated it. There was no in between.

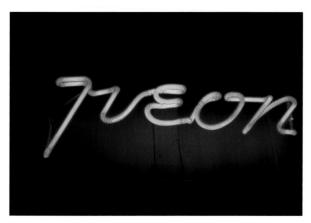

From the authors' neon collection, 1993.

The heart came to us first. It was an impulsive Valentine's Day present, custom fabricated at a neon sign company in Sparks. It seemed natural for Valentine's. We were surrounded by Nevada neon, and glowing neon hearts were not uncommon throughout the state—adorning wedding chapels and motels.

We found Neon hanging out in front of a high desert sign shop, the last sign left. No work had been done in the dusty shop for quite some time; all the tools and other equipment were packed. The store was going out of business.

"Would you consider selling the Neon sign?" we asked the owner inside.

"I really hadn't thought about it," she told us. Her husband, the sign maker, had just died. The sign neon was just a business for her, and it was not a business that she was interested in continuing. We were disturbed to learn that she had just junked a pile of his old handmade signs into the dump. There they had fractured into little pieces. Neon was all that was left of her husband's stock.

"Will twenty-five dollars be fair?" she asked.

"With the transformer?" By then we had developed an understanding of what makes the tubes glow, and we knew that in order to light up, neon signs require a transformer specially designed to bombard the gas or gases in the tube with a specific high voltage.

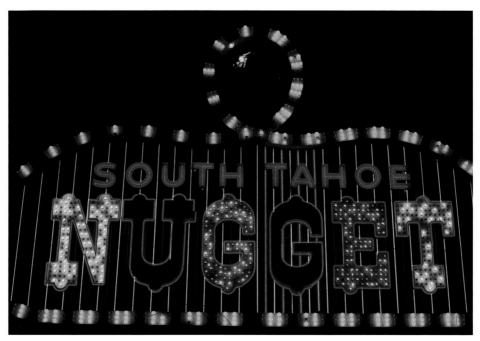

South Shore Nugget, Stateline, 1978.

"Yes, I'm sure I've still got one around here somewhere." And we struck the deal.

Riding home, we talked about those dumped neon signs and the changes occurring on the Nevada neon landscape. The Nugget in Carson City was remodeling, and the hundreds of reflecting gas-filled glass stripes along the sidewalk were being replaced with plastic and incandescent light bulbs. We reminisced about some of our favorite neon, still lit and flashing: All the cowboys with flying lassos, the fortune telling outstretched palms, and the palm trees; the bearded neon fellow at the Merry Wink motel, the romantic neon of the old motels along

Nevada's outline in the Las Vegas Boneyard, 2010.

the Boulder Highway, and the dice and playing cards on the old stone wall in Tonopah. High are on our list was our old friend, Wendover Will.

That was when we decided to travel all around Nevada, saving the signs that were still left. Of course we would never want all of them up on our living room walls, but we were determined to capture them on film.

Our search for select Nevada neon required that we crisscross the state, just looking. There was no catalogue available of where the signs are located, and many local townspeople were unaware of just what illuminated the advertising surrounding them. Our travels became a nocturnal treasure hunt, as we headed for the lights of both cities and crossroads, calling out to one another when one of us saw a telltale neon glow in the distance.

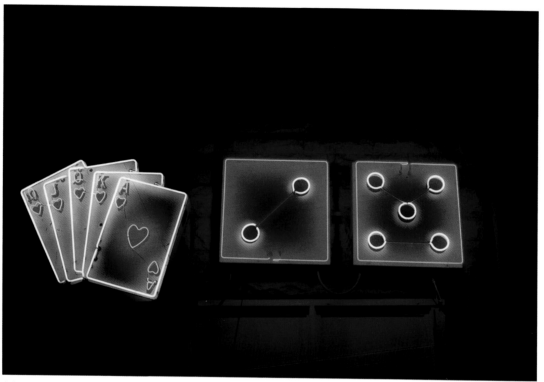

A lucky royal flush and craps light up Tonopah, 1978.

It was often the case as we cruised Nevada looking for neon that after we explained our quest, longtime Nevadans, merchants and townspeople, were eager to point out the signs they liked the best or to join us in lamenting the passing of some of the traditional-style typography and pictorial images.

We talked with the signs' owners and the craftsmen and artists who created and maintained the neon. We heard the lore from locals about the role neon

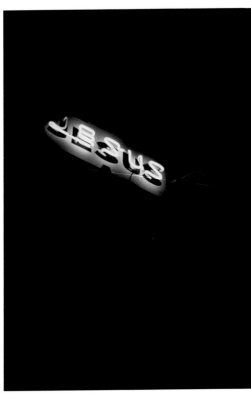
Jesus Saves, Reno, 1978.

played in their lives. And we enjoyed both the visceral and an aesthetic satisfaction from just watching the vibrant colors in motion, no matter what their intended message: all the argon violets, krypton purples, helium golds, and xenon blues that glowed along with the red neons.

We found the Reverend Howard Cooper at the Reno-Sparks Gospel Mission. There was a huge Pabst Blue Ribbon sign on the side of his building when he took it over for his church. The Reverend had written to the beer company and asked them to remove it. "We didn't want a beer sign. That's the main problem with the guys," he said about his parishioners, "they're in bars." But Pabst wasn't interested, so the church painted over the beer ad and installed a neon cross. "We wanted a cross, so we made one up." If you looked closely, you could still see the *Pabst* faint behind the cross.

"Nevada should have neon," sign maker Bob Glave told us from his Sierra Signs office in Minden. "Without neon and flashing lights, you might as well be anywhere." But at that time his business was hurting—the use of the gas-filled tubes for signage was out of vogue. "I see it going down the tubes," he tried to

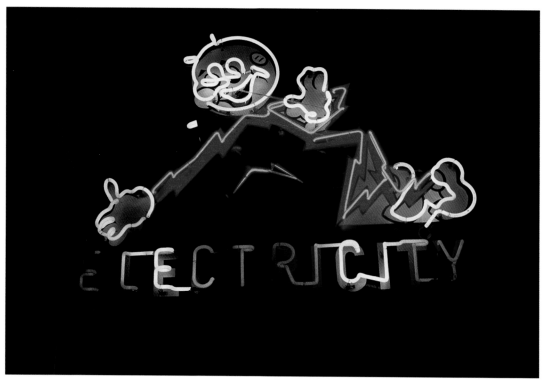

Reddy Kilowatt, Elko, 1978.

joke. But he was sorry to see the medium fade, and not only because he made his living from it. "Neon is exciting," he insisted. "Neon excites people. Neon and flashing lights mean Nevada."

Many casinos in the late 1970s were eager to update their facades. "People don't think of gambling as a sleazy business anymore," the manager at the Southshore Nugget said. "So we don't need the flash-flash of the neon signs." As

if by its very nature neon carried a negative connotation, he emphasized, "We're selling clean entertainment." His crews were busy replacing the vibrant and colorful glass tubes on the casino walls with rustic redwood paneling.

We made our way out to Elko, musing about all the references to neon in American popular culture, particularly music, from the bright neon lights of Broadway, to the long list of country and western tunes, to Paul Simon's lyrics, "and my eyes were stabbed by the flash of a neon light that split the night." The intensity of the neon image translates well into poetry.

Elko was a living neon museum, from the leggy redhead bathing in the martini glass at the Sandpiper Lodge, to the caricature of Shorty in front of his old bar, to a partially burned-out Reddy Kilowatt advertising the Elko Power Company.

With hundreds of images eventually collected on color transparencies, we ended our first Nevada neon tour in downtown Las Vegas, bright as day in the middle of the night, then the quintessential Nevada neon experience.

To preserve the signs we used a handheld Pentax Spotmatic camera and Kodak Ektachrome film with an ASA speed of 400. Most of our shots were made at $\frac{1}{60}$ of a second—when the signs cast enough light we shot at $\frac{1}{125}$—with a pretty wide-open lens, between f/2.8 and f/4.

Almost two decades later, searching in our garage, we retrieved the binder full of our original neon transparencies, the film still in pristine condition. We had filed them away after publishing photographs of a few signs from our collection in *Nevada* magazine. By that time many of those photographs documented neon long gone. We looked through the pictures and determined that it was time for a return trip. We wanted to see which signs were still shining, and discover whatever new ones had shown up during the neon renaissance that started in the late seventies after our first trip around the state.

Again we toured the Silver State and found a scattering of new neon but were sad to learn that many of our old favorites were decrepit or had disappeared. Using the same camera and film, we documented changes for the first edition of *Neon Nevada,* published in 1994 by the University of Nevada Press. The journal of the Art Deco Society of Washington called it "one of those books that, once you see it, you wonder why it wasn't done years ago," and the Nevada Historical Society Quarterly said the pictures and text "provide testimony to the disappearance and dilapidation as well as the current renewed interest in neon."

Almost another two decades later, the original edition had become a collector's item. Instead of simply reprinting it, we decided to take the neon Nevada trek once again. The Las Vegas Strip had been transformed into a family theme park and was all but neon free. The Neon Museum was about to open for business. We realized our passion for the art and craft had not waned, and we wondered about neon changes in the Battle Born State at a time when neon finally was officially honored with a museum of its own.

Armed with our good old Spotmatic refurbished as new and a bag full of Fujichrome Sensia 400 (Kodak stopped making Ektachrome years before), we landed in Reno, rented a fast little Subaru, and headed out.

Few Neon Reflections Splash at the Lake

On a bitter cold winter night we made our way back around Lake Tahoe, looking for the remnants of neon that still glowed in the early 1990s. All of our neon prospecting trips through Nevada were in the colder months. The skies are clearest in the crisp autumns and winters, and the neon appears to shine brighter than in the summer. And, of course, there are more hours of darkness to work with after the fall equinox.

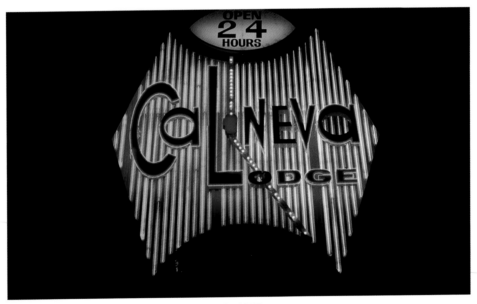

The Cal-Neva Lodge, Crystal Bay, as it was in 1978.

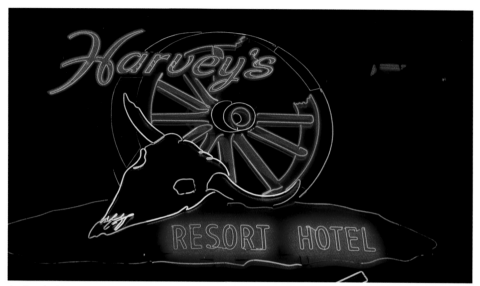
A classic Nevada neon scene, now gone, Stateline, 1978.

There is very little flashy neon remaining on the Nevada side of the Lake. Restrictive sign ordinances conspired with energy crises back in the 1970s to doom plenty of the gas-filled signs. As the Nugget at Stateline was pulling down its neon, the manager insisted the sign would have been replaced with plastic even without the new laws. "They're out of date," he said about the glowing letters, not anticipating the resurgence of interest in neon that was occurring not only in Nevada, but all over the world.

All that was left of the flashing and flowing neon at the Nugget those days were subdued glowing outlines suggesting nuggets of gold, reminiscent of the outlines of pinecones just down U.S. Highway 50 at the Pinecone Resort. The old wagon wheel and bull skull that served for years as a beacon on the rooftop of Harvey's Resort were gone, too.

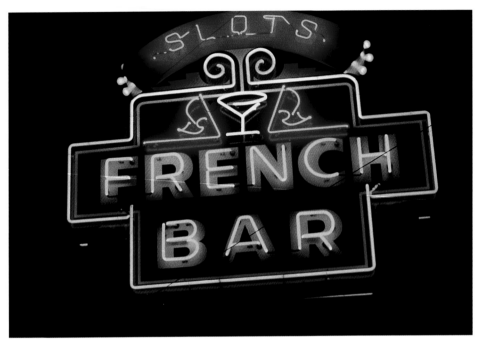

The renovated French Bar, Gardnerville, 1992.

The old sign maker who had told us, "Nevada should have neon," as he remembered the glitz that adorned so many of the Tahoe resorts, suggested that without the dancing neon lights, "you might as well be in California." Since neon went out of vogue at Lake Tahoe casinos there was, in fact, more of a light show on the California side, where many of the old fashioned motels lining the shore still maintained their neon identities.

Driving in from California at the north end of the Lake, some sudden sparkle still marked the Nevada side as the darkness gave way to the flashing lights

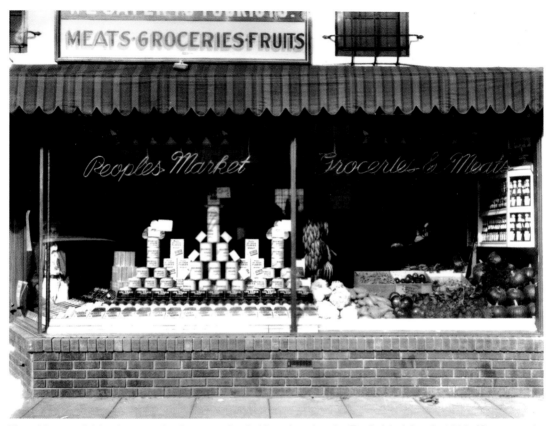

MEATS·GROCERIES·FRUITS

The oldest available photograph of a neon sign in Nevada, taken by Frederick Jukes in 1928. (Courtesy of Nevada Historical Society, Jukes Collection)

identifying the Crystal Bay Club. But there was nothing special to us about the old sign there: the colors were ordinary; it painted no pictures; the typography was commonplace. Back when the Crystal Bay Club was the Ta-Neva-Ho, it

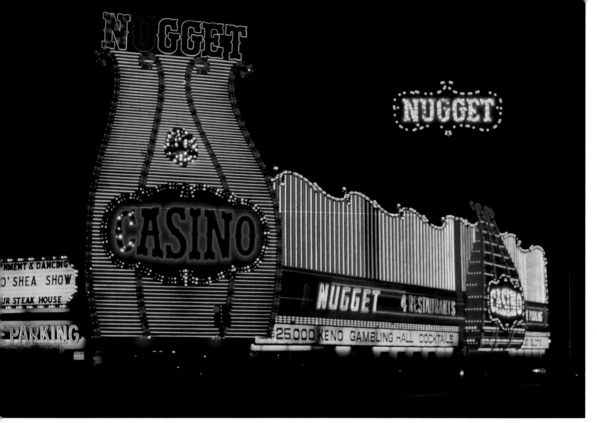

The old Carson City Nugget façade, 1978.

was equipped with more alluring neon calling out the odd name of the casino and advertising its "American dinners and gambling." Across the highway, at the Biltmore, neon was consigned only the routine job of marking the hotel entrance. Having found only a few hackneyed Coors and Miller neon beer signs in Incline Village liquor store windows, we left the Lake without much more than frozen fingers, heading east and wondering if all the remarkable neon

lights were gone from the rest of Nevada, too.

Down the mountain in Minden and Garnerville, the urban sprawl in America's then fastest-growing state offered no new neon. But in the old center of Gardnerville, the Overland Hotel still advertises itself with an oversized neon martini glass filled with an equally big olive on a toothpick; the neon looks leftover from the late 1940s or early 1950s. In case the message is missed, the word *cocktails* glows through the glass stem.

A few doors down, the competition, the French Bar, uses its old neon—a sign that the owners restored in the early 1990s and painstakingly maintain—to remind customers about its martinis and its slot machines.

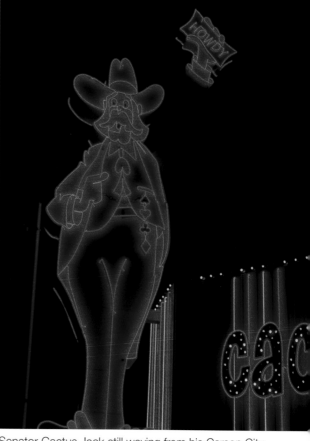

Senator Cactus Jack still waving from his Carson City casino in 1992.

But most of the new businesses filling the shopping centers and lining the new four-lane road used plastic for identification. We headed north toward the lights of Carson City, where the official neon that once adorned the Ormsby County courthouse—to light the path for anxious Californians seeking a fast marriage—is long gone, but some classic

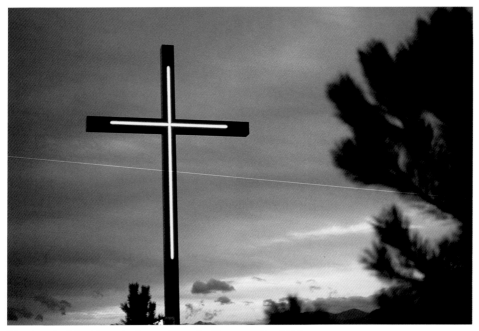

Shepherd of the Sierra Lutheran Church, Carson City, 2010.

examples of the neon sign makers' art still glow and flash. Where there was sagebrush and juniper now sit endless chain stores. Their signs are mostly backlit plastic light boxes without any unique Nevada style.

Just south of town we spotted a stark image calling the faithful, Nevada-style, to services. It's a simple white neon cross, stunning in the dusk. We crossed the four lanes and switched back to the Shepherd of the Sierra Lutheran Church— our congregation of two to capture that new beauty.

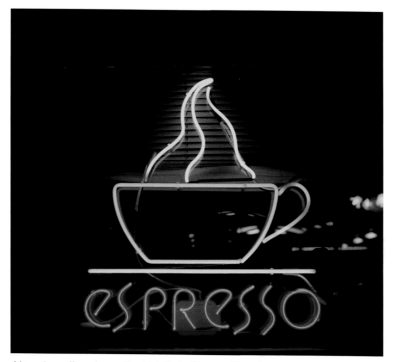

Nevada coffee shops like Heidi's in Carson City change with the times, 1992.

Neon first showed up as an advertising medium in Nevada in the late 1920s. Frederick Jukes's photograph of the old People's Market in Elko is the oldest documentation of Nevada neon at work; the date on the back of the picture is 1928.

The process of sending an electric charge into a sealed tube filled with inert gas to create illumination had been developed years before by the inventor Nikola Tesla. He transmitted the electrical charge needed to excite the gas through the air; no wires connected his tubes. Tesla lined his laboratory with the

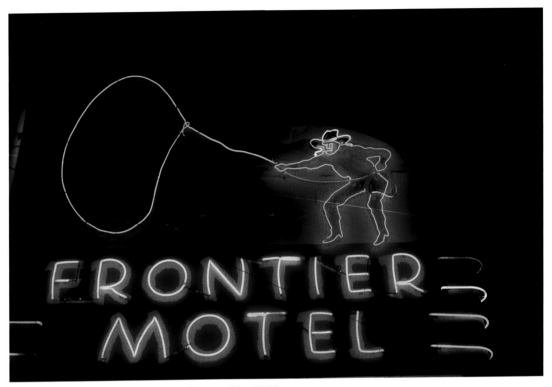

The Frontier Motel cowboy at work, Carson City, 1978.

glass tubes, bent into stars and other shapes or spelling out words. The glowing tubes were his preferred method of illumination for his laboratory.

The concept was developed further by Georges Claude, who patented the basic system that is still in use. Electricity passes through a transformer and into the glass tube via electrodes at each end; it excites the gas molecules in the tube so that they emit light. Claude patented his device in Paris in 1910 as an

The Blue Bull Bar, Carson City, 2010.

alternative to incandescent light and is credited by neon historians with developing neon as a vehicle for advertising. In 1923, the bright neon lights of Paris inspired Earl C. Anthony, a vacationing Packard dealer from Los Angeles, so he brought the neon home to his showroom. His shimmering sign was an instant success, and neon as an advertising tool headed across America. Soon after the People's Market sign was plugged in, the first neon lit up in Las Vegas, and the glowing gases started their spread across the Nevada desert.

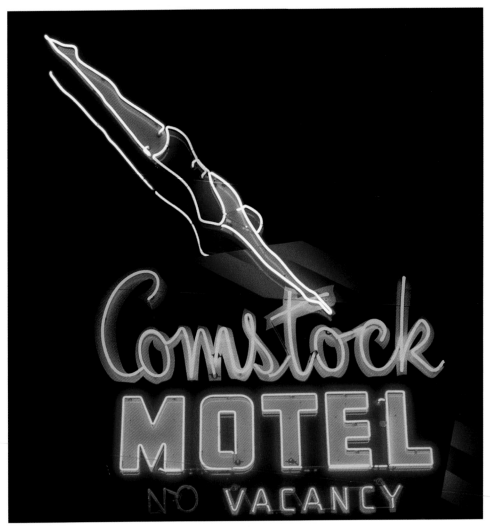

The Comstock Motel, Carson City, 1977.

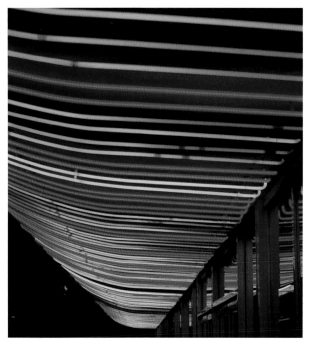
Neon canopy, 1978.

The mass of golden neon that used to flash from the Carson Nugget—long promoted by the Nugget management as sizzling with more gold-colored neon than any other casino sign in Nevada—no longer lights up the capital's main street, but the dapper neon politician towering across the street at the Senator Casino is still alive and well. From high above the casino, he waves and waves at passing traffic. The money in his hand spells out a neon "Howdy," and the watch fob in his vest pocket is decorated with a heart, a spade, a club, and a diamond.

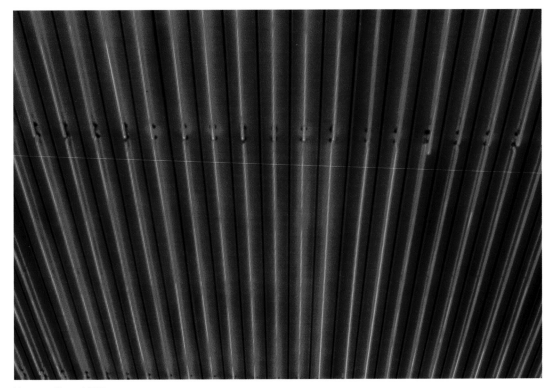

Neon ceiling, 1978.

We saw some new neon in Carson on our second tour. At Heidi's Restaurant a frothy cappuccino steamed in the window along with the explanatory word *espresso*. And a picture framing shop offered to add a curving tube of glowing color to any picture, a service they call "Neon Art" and advertised in their window with a neon flourish accenting the famous photograph of Marilyn Monroe with her dress blowing up her legs.

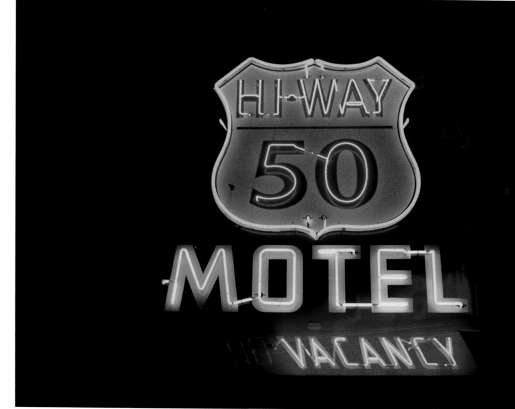

Hi-Way 50 Motel, Carson City, 1978.

At the north end of Carson, an old miner called attention to the 49er Motel. His neon fingers held an incandescent golden lightbulb—his nugget. But at the 49er Motel, sign maintenance was not pressing business. The gold nugget lightbulb was burned out.

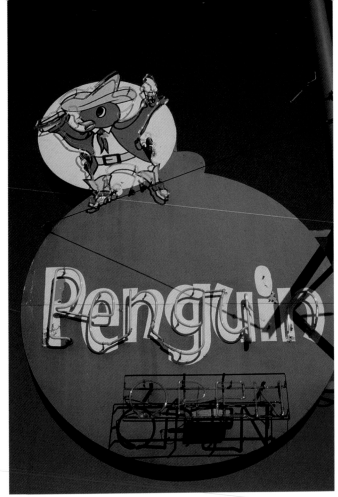

The Penguin, broken but restorable, Carson City, 1992.

Vandals, wind, rain, and snow wreck neon. Business owners repeatedly told us that repairing the signs was too expensive; many signs are simply left broken. The little gun-toting penguin cowboy waving a hot dog and an ice-cream cone from the roof of Carson City's landmark Penguin Drive-in was suffering from neglect when we last saw it in 1992. The electrical connections to the sign were severed, and the glass tubing was smashed. After getting a repair estimate, the owners decided the sign was "too expensive to fix." When we returned to Carson not only was the penguin himself missing, his drive-in was a memory, too.

Farther up the main street the sign on the Frontier Motel was still lit. It showed off one of neon's fanciest tricks—a gangly cowboy working his animated lasso performed all night long. To make the sign come alive, neon tubes overlapped one another along the outline of the looped rope, and three distinct patterns flashed one after another, providing the impression that the rope was twisting through the air. In late 2010, we saw that cowboy looming over Carson's main street again, and were gratified to learn that he's lit up every night—as he's been since he arrived on the scene in 1953—even though his bunkhouse has changed its name to the Royal Inn. The janitor told us the sign is maintained as a Nevada landmark. Heidi's, however, has lost her espresso.

But a few blocks south, on a side street across from the landmark Nevada State library, we found the Blue Bull Bar on our third jaunt, a local hangout sporting a brand-new blast of neon. Unmarked with words, a neon bull endlessly butts a martini glass that keeps bouncing so fast it's almost a blur. The place feels like a new version of old Nevada. Behind the bar a sign offers quarter dice rolls for drinks. Five of a kind wins the eighty-one dollar pot tonight, four of a kind and your next slug is on the house, three of a kind lets you roll again. The Friday night crowd is enjoying happy hour while the Rolling Stones's "Sympathy for the Devil" plays in the background. We have a glass of wine and won't be stopping again for a while. It's time to hit the road, searching for those special glows in the night.

The Biggest Little City in the World

Heading into Reno on U.S. 395, one of our old favorites—the bearded neon fellow with the top hat—continued to make a game attempt at luring tired travelers like us on our second neon trip. He winked all night long, but only on one side of his billboard, still summoning the weary to his Merry Wink Motel, although the motel no longer catered to overnight guests. By late 2010, his wink

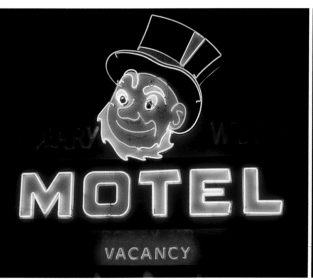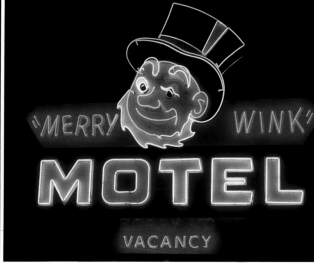

The Merry Wink Motel, Reno, 1977.

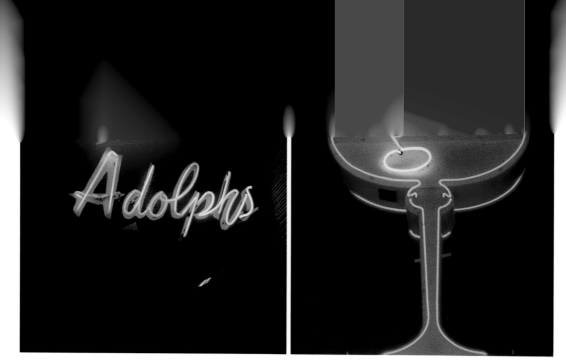

Two of the scores of Reno martini glasses, 1993.

was long gone. The sign was battered, broken, and sad. However, its future is bright: Will Durham, an artist, fellow neon lover, and sign collector, bought the Merry Wink. The deal he made was to leave the sign in place until the owners decide to take it down. Next door a subtle, green neon ponderosa pine glowed gently adjacent to the soft yellow marking the Evergreen Trailer Park.

We caught up with Will Durham and learned that he fell in love with neon as a young insomniac in Reno. "I could always look to downtown," he told us, "and see the glow of the neon, and that comforted me." Durham started collecting

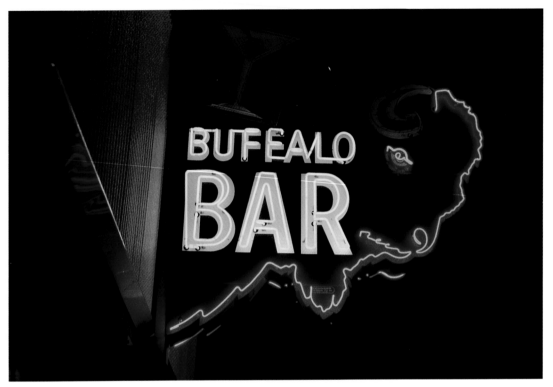

Buffalo Bar, Sparks, 1978.

neon in the late 1990s. He watched casinos and bars with flamboyant pictorial signs go out of business and rushed to salvage the neon. "I just hated to see all this stuff being destroyed, so I just started collecting as many as I could." He wanted to preserve what he was watching disappear, hoping to open a museum someday in downtown Reno. Durham owns some thirty old neon icons, including pieces

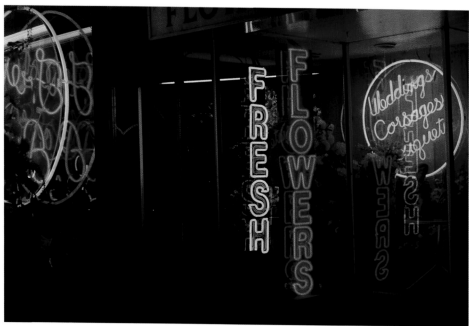

Fresh flowers, Reno, 1992.

from Harolds Club, the Nevada Club, the Buffalo Bar, Adolphs, the Brandin' Iron, and the Flamingo—all places we photographed. We rarely meet others as avid about neon as we are, and it was gratifying to hear his enthusiasm. "Your book really inspired me. I drove all through Nevada looking for signs that I knew were there because I had seen them in your book."

Reno and neon grew up together, but Durham is sure, "you don't have to know anything about Reno history to appreciate this stuff." When he salvaged

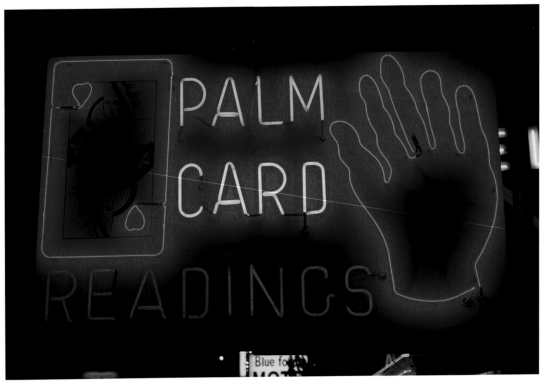

Fortune teller, Sparks, 1978.

neon letters from Harolds Club and the Nevada Club he convinced the city to shut down a block of Virginia Street and he hired a crane to save the treasures. When asked by passersby why he went to the trouble and expense, he rhapsodized about the medium. "I see something so beautiful in neon and know: That's why."

Olives soaking in neon martini glasses dot the Reno landscape, dozens and dozens of them. Some, like Adolphs, tipped precariously. Others, like the one at the Zephyr, tilt suggestively, offering a glimpse inside the glass at the drink. Many simply crown a bar's name, resting with an imposing liquid presence, identifying saloons where martinis rarely are served. We drove lazily through the older side streets of Reno and Sparks finding one martini after another, happy to see that many of the bar signs still survive.

Some merchants recognized both the beauty and the historical value of their neon. "I like the old exposed neon," the proprietor of the Del Mar Station restaurant said to explain his investment in the lacy blue light that outlined

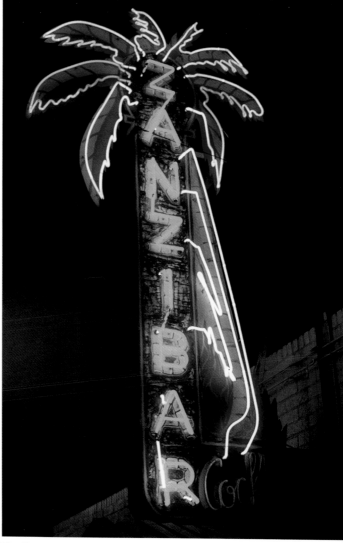

The Zanzibar, Reno, 1977.

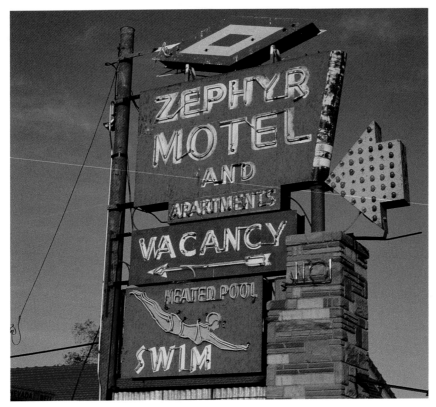
Defunct motels on old U.S. 40, Reno, 1992.

his building. The looming electric palm tree marking the Zanzibar since the late 1940s also was protected by the bar's proud owner. "As long as there's a Zanzibar," said Red, "that sign will be there. I think it's as old as I am." When we cruised South Virginia Street in 2010, there was no sign of the Zanzibar.

What we did spot once on Reno's main street were examples of neon artist Jeff Johnson's work. Johnson repairs old signs, custom makes new ones, and creates neon artworks. We were entranced to see his amazing installation of neon trout in the Truckee River—the fish wired to transformers, their tubular outlines blazing bright underwater. "I was thinking about how the neon works outside in the rain and snow," Johnson told us when we caught up with him years later, "and I wondered what the limits were."

The trout lit up in sequence, appearing as if they were alive, swimming upstream through downtown. "I was looking out my friend's apartment window and I came up with the idea of having fish in the river lighting sequentially in different

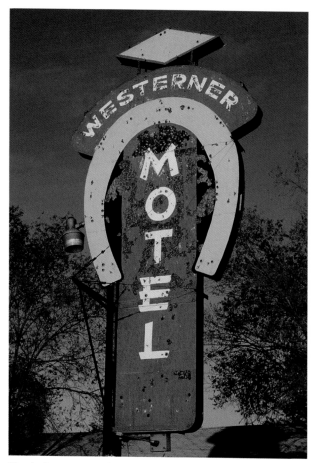

The luck ran out at the Westerner, Reno, 1992.

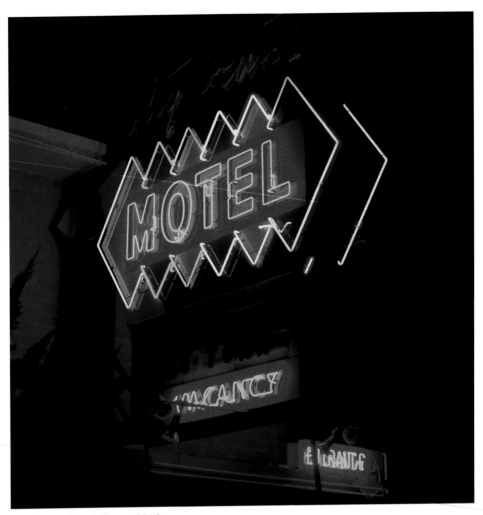

City Center Motel, Reno, 2010.

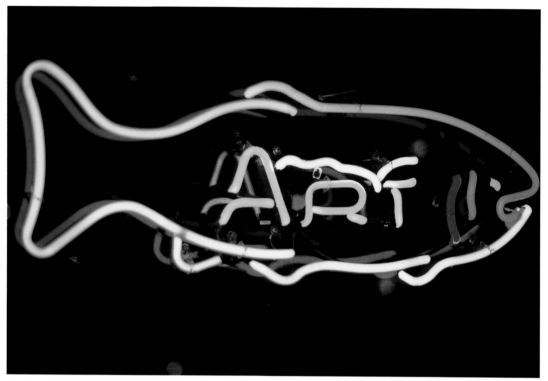

Neon fish along the Truckee, Reno, 2010.

patterns to represent the cutthroat trout that used to run out of Pyramid Lake to their spawning grounds." The two-foot long neon fish swam along two blocks of the river, a great crowd pleaser. The neon word *art* sits in the belly of one of Johnson's river trout, a sign displayed in a window of Reno's Brüka Theater long after the installation was pulled from river.

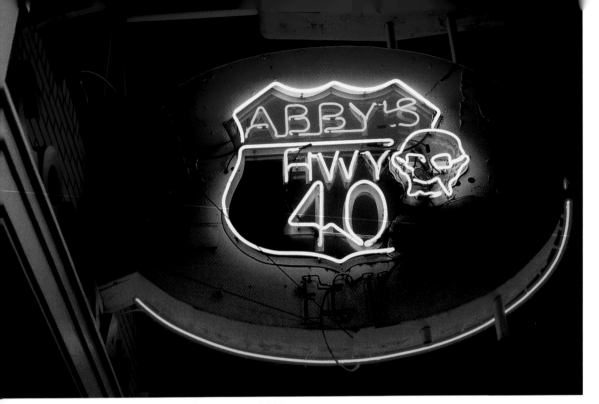

Abby's Hwy 40, East Fourth Street, Reno, 2010.

Back in the early 1990s along the Truckee, the World Famous Sky Room sign at the defunct Mapes Hotel was decaying. The sign was surrounded by barbed wire, its tubes were broken, and its majestic cowboys, wearing chaps made out of the towering letter M, were then home to pigeons. Other crumbling classic neon signs hung on along old U.S. 40 heading west out of Reno, promoting motels that no longer served travelers but housed permanent residents. At

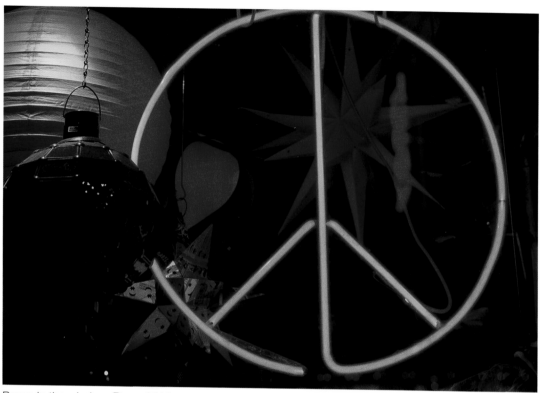

Peace in the window, Reno, 2010.

the Zephyr Motel and Apartments a yellowing bathing beauty is suspended in her glass-tube two-piece suit, mid-dive and unlit. "Swim," offered her sign, and "heated pool." But no one swam in the dirty drained pool. Next door the Western Motel sign was stripped of all wire and glass. Its horseshoe emblem

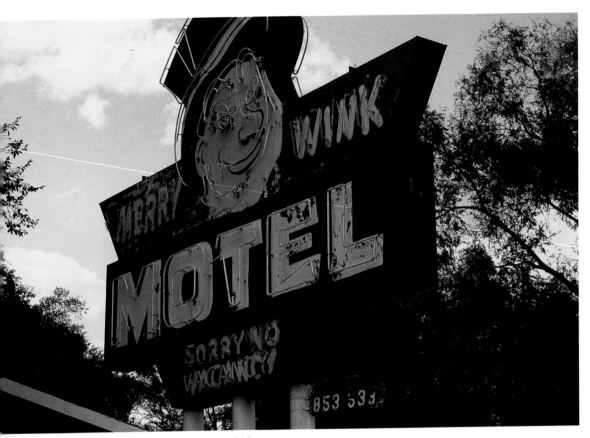

The Merry Wink Hotel, Reno, 2010.

was painted upside down, a dangerous mistake—any old Nevadan knows—because all the luck runs out.

When gambling was legalized in Nevada in 1931, the downtown Reno casinos quickly adopted the flashy electric neon signs that were already calling attention

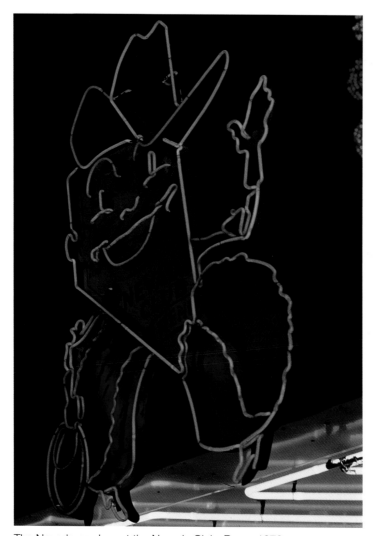

The Nevada cowboy at the Nevada Club, Reno, 1978.

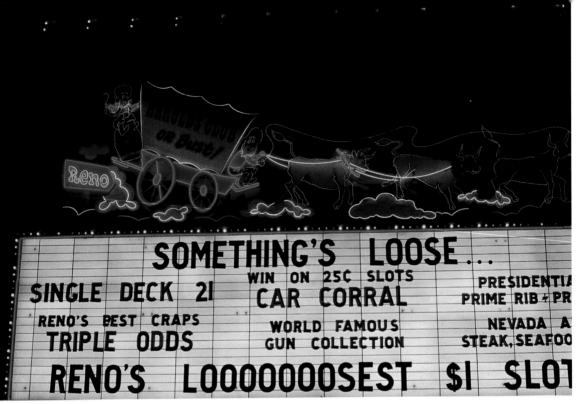

SOMETHING'S LOOSE...

SINGLE DECK 21 WIN ON 25¢ SLOTS PRESIDENTIA
CAR CORRAL PRIME RIB + PR

RENO'S BEST CRAPS WORLD FAMOUS NEVADA A
TRIPLE ODDS GUN COLLECTION STEAK, SEAFOO

RENO'S LOOOOOOOSEST $1 SLOT

Harold's Club, Reno, 1992.

to other Reno businesses. The first Reno arch added to the neon dazzle in the 1930s and proclaimed across Virginia Street the now famous legend, "The Biggest Little City in the World." After that original arch was retired from center stage it fell into disrepair. Restored, it was moved to the Lake Street bridge across the Truckee, to be displayed as a public reminder of Reno's glorious heyday.

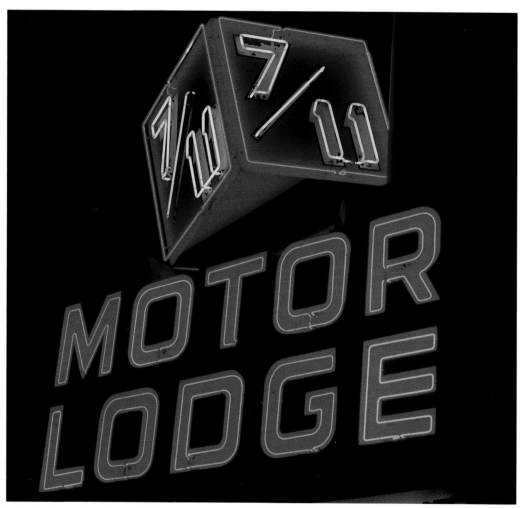

7/11 Motor Lodge, Reno, 1978.

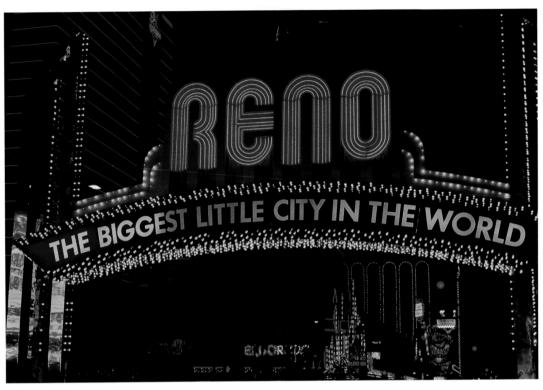

The Reno arch, 1992.

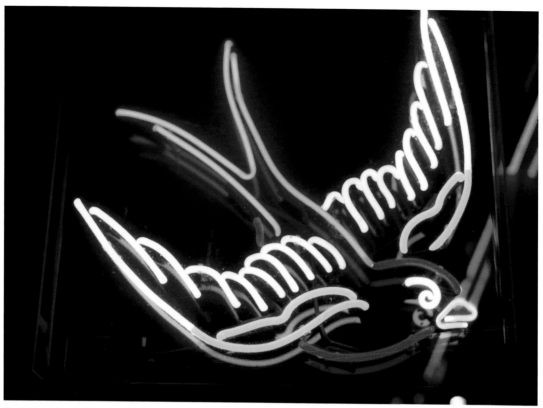

Rainbow Dove, Reno, 2010.

The new arch over North Virginia Street shined on with abundant neon, and there was new and old neon all around it on Reno's downtown strip, radiating in abstract glory across the facades on the casinos, painting detailed pictographs of Western history, even lining the sidewalk with a distinctive red glow. By 2010, most of those old signs were glaringly absent.

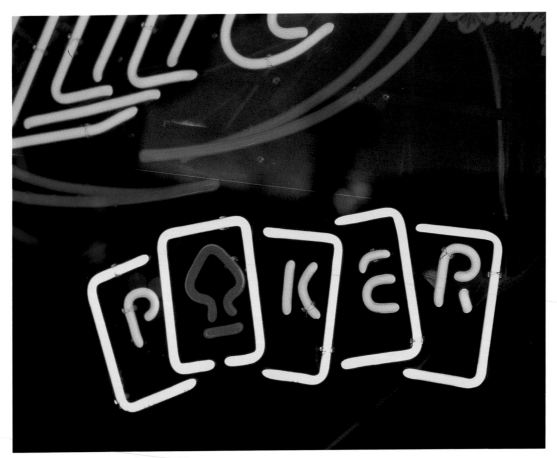

Miller Lite Nevada style, Reno, 2010.

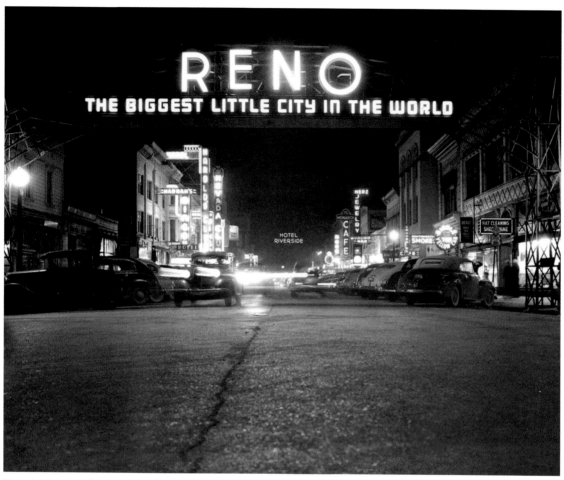

The old Reno arch, ca. 1940. (Courtesy of Nevada Historical Society, Neal Cobb Collection)

Chapter Four

Rural County Casinos and Bars

Much of Elko still felt like the late forties and early fifties when we searched its streets and alleys in the 1990s—prime days for neon signs, especially signs with intricate messages carried by graceful script and flashy pictures of cowboys and martinis. Many signs in Elko continued to beckon travelers toward casinos, bars, and motels with the brilliant colors unique to charged gases. Some glowed in their full fluid glory; others flickered in need of repair. We had returned to Elko looking for two more of our favorites.

Shorty ordered a sign with his own caricature back in the 1940s when he opened his bar downtown along the railroad tracks that cut through the heart of old Elko. "I've always been called Shorty," he told us when we first talked in the 1970s. "So I went to the sign company and told them I wanted a Shorty. They did a real good job. It looks just like me."

Not long after we talked, Shorty sold the place. One of the partners who bought the bar used the Basque nickname Chappo. With the kind of coincidence not uncommon in Nevada folklore, *chappo* is a Basque slang word meaning "short," so the new owners held on to the old sign.

But by the time we arrived back on Railroad Street the saloon had changed hands again, this time adopting the name Goldie's. "It hasn't been Shorty's for a long time," the bartender told us, "seven or eight months." She did not know what had happened to Shorty's old sign, but she told us, "Shorty is still around." Other old-timers helped us track him down.

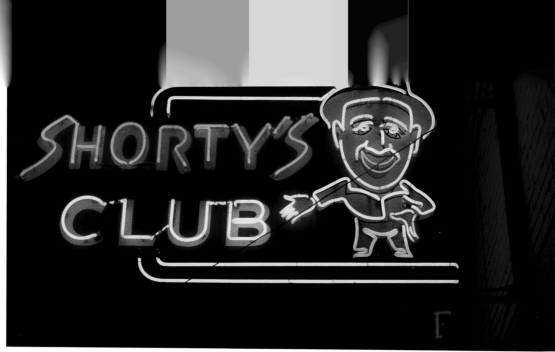

Shorty's Club, Elko, 1978.

When we caught up with Shorty, he told us he had lost track of his sign. "I don't know what happened to it," he said. "The sign never did belong to me." As is the case with so many business owners, he leased the sign from the sign maker. Along with much of Nevada neon, Shorty's sign came from YESCO, the Young Electric Sign Company.

"It stayed up when Chappo bought the bar. But when the new outfit took over, YESCO took it back to Salt Lake." Shorty seemed sad. "I imagine it's in the junk pile or something." A forty-year Elko landmark was gone.

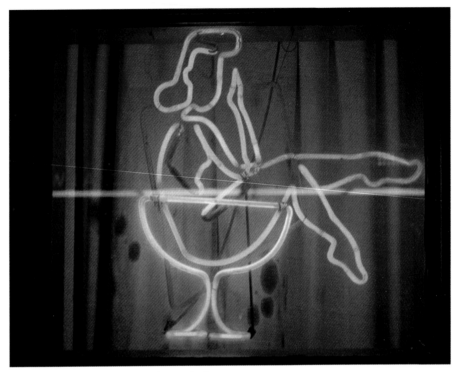

The lady from the Sandpiper, Elko, 1978.

The best neon martini glass in Nevada was gone, too. We wandered around Elko showing off our picture of the Sandpiper Lodge's lady, with her forties-style hairdo, who used to lounge in a martini glass. We had had her distinctive and suggestive profile made into postcards, and the original photograph had been lost during the production of the cards. We were eager to see her again and make a replacement transparency for our collection. "Have you seen her?" we asked in

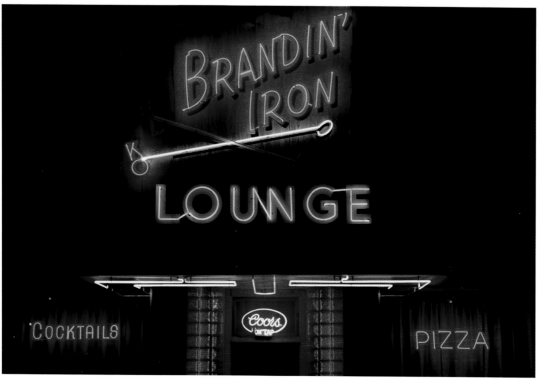

Brandin' Iron, Elko, 1978.

bars, casinos, even at the library. But along with the old People's Market script, the Sandpiper lady, glowing to passersby in front of her stained window curtain, is just a memory.

Years later we thought we spotted her in a Reno window along the Truckee River, but something about her looked slightly different than the original. We learned the Reno martini lady was a replica, made by neon artist Jeff Johnson.

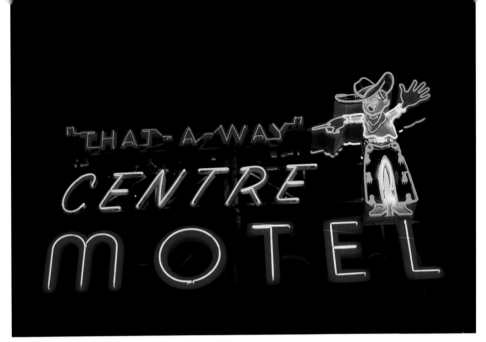

"That-a-way" to the Centre Motel, Elko, 1978.

"It's from your picture in your book," he told us. "That's the best part of your book, it shows a time that has gone past. It's left us behind." Johnson crafts his works with old-fashioned techniques: He sketches out his designs with pencil on paper and blows the glass to match.

We systematically cruised the dark streets of old Elko, searching for what is left of the neon and periodically finding some new works. An electric rose was blossoming in the window of a dress shop called Country Elegance. Spotting one of the old signs was like seeing an old friend. We found the Brandin' Iron with its hot KO brand glowing red. The excited cowboy still waved down cars on Idaho Street, pointing and saying "That-a-way" to the Centre Motel. The big blue star

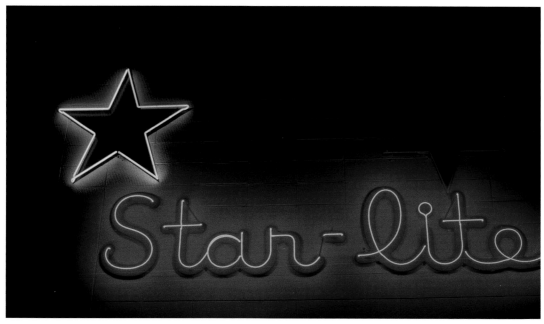

Star-lite, Elko, 1978.

at the Star-lite Motel was lit. And the electric dollar sign burned brightly on the Club Silver Dollar. The old neon words and pictures are all electric archaeological treasures, signs of passing times.

West of Elko we followed Interstate 80, the cross-Nevada route that shadows the original Humboldt River trail. Along the railroad tracks in Carlin, only ruined hulks remain of the old downtown. Businesses, including the State Bar and Cafe, had moved up toward the new freeway. The State Bar just left its old shell to decay, and like so many other businesses in the boom and bust of Nevada history, it abandoned its broken neon sign. Most of the glass gone, the painted

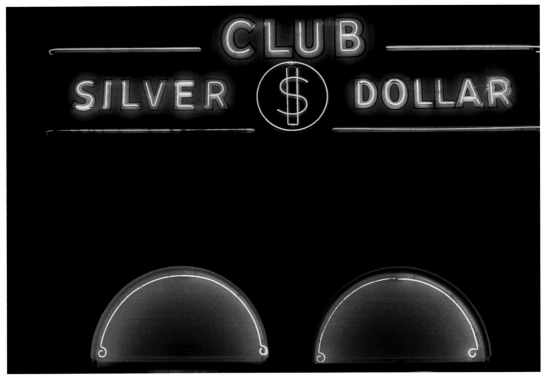

Club Silver Dollar, Elko, 1992.

backboard peeling, and just a few fraying wires still ran from letter to letter. Slowly the sign was being reclaimed by the desert.

Lovelock, too, holds neon memories. The Oasis Bar was closed for good; its blowing neon palm tree no longer suggesting a tropical interlude to passing railroad crews. The laundry down the street still operated, but its neon clock was stuck at 5:59, and the broken tubes that once spelled out *laundry* and *cleaners*

clung to their wires, skewed dis-
jointedly across the clock face.

It was the same story just
outside Winnemucca years ago,
where an old, battered, neon-
filled billboard for a Union 76
truck stop weathered for years. A
spectacular old sign, it showed a
truck flying over the Welcome Inn
cafe. The driver looked confident
under his uniform cap, a neon
swan hood ornament leading his
way, a neon air horn attached to
the truck cab's roof. Those ruins
are gone now, replaced by the
sprawl of growing Winnemucca,
but a flashy neon revival just up
the street provided some com-
pensation for the loss.

Driving down the main street
of Winnemucca, our eyes were
attracted by an exciting find, a new
neon piece in the old tradition: a
fat sparkling-blue pig equipped
with flapping golden wings.

Inside the Burns Brothers truck stop, Mill City, 1992.

"Don't see many of those, do you?" was the ready response to our inqui-
ries from Lee Armstrong, the proud proprietor of the Flyin' Pig Bar-B-Q. "It's

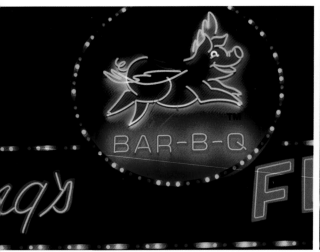
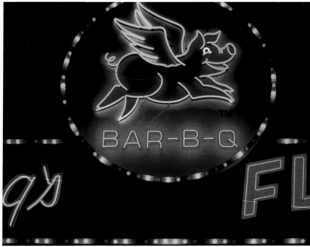

Lee Armstrong's Pigasus, Winnemucca, 1992.

Nevada." He was charged with enthusiasm for his airborne pig. "It wasn't going to be a flapper, but when it was made in Boise, the owner of Golden West Advertising said, 'You're missing the boat if you don't make that pig fly.'"

Armstrong loved to talk about his then new blue-and-gold animal. "People say I've got the neatest sign in Winnemucca." He did, but as we explored the old Oregon Trail stopover we found more neon gems tucked away. On the east side of town, subtle stripes of neon sketched the rooflines of the Frontier Motel and its companion across the street, the Stardust. Scott Shady Court lit up a side street with its vivid oranges and turquoise blues. Close by, the ice-blue letters of the Covered Wagon Motel matched perfectly with the bright pink that spelled out "Motel." A pink-red wagon wheel still spun sporadically across the old sign.

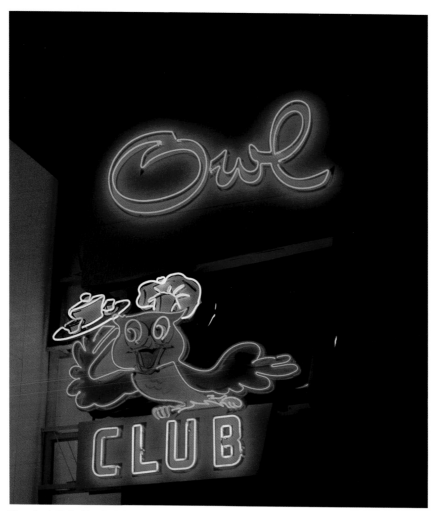

The Owl Club, Battle Mountain, 1992.

Another pocket of aged neon was just east on the interstate at Valmy, where Gene's Golden Grill was still in business along old U.S. 40 at what is the Valmy freeway exit. The naugahyde-covered swivelstools at the Golden Grill lunch counter complemented the golden neon sign on the roof. Next door more neon announced Gene's companion businesses, the Golden Auto Court and the Golden Motel. The motel's rooms and the typography of its signs, both left over from generations past, promised a "Beautyrest."

Wandering the Neon Desert
from Wendover Will to the Oasis

Vegas Vic was the first gigantic neon cowboy to call out to tourists looking for a good time. He still looms over Fremont Street in the old downtown Las Vegas, a jaunty cigarette flipping in his mouth.

Vic was built for $90,000 back in 1951 by Thomas Young, the founder of the Young Electric Sign Company and purveyor of much of the early neon in Nevada. According to company lore, Vegas Vic was a bad business deal, a money loser for Young. So Young scoured the state looking for an opportunity to build another giant and make money at the job. At Wendover he asked the casino boss how much he paid his card dealers—and offered to lease the casino a big neon cowboy for the same $36

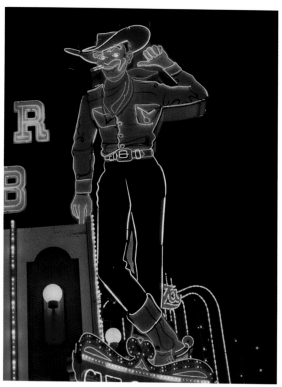

Vegas Vic presiding over Glitter Gulch, Las Vegas, 1992.

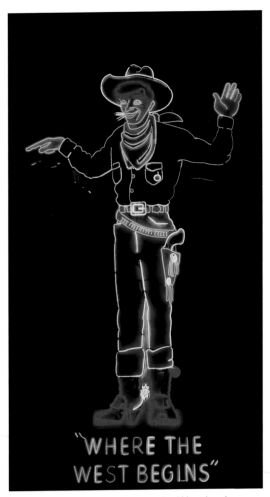

"WHERE THE WEST BEGINS"

Wendover Will marking where the West begins, Wendover, 1978.

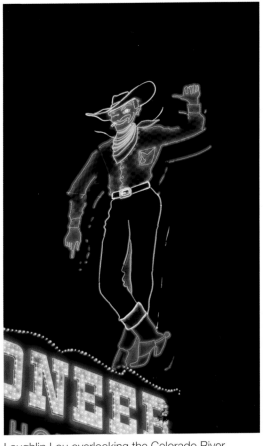

Laughlin Lou overlooking the Colorado River, Laughlin, 1992.

Dawn at the Sagebrush Ranch, Moundhouse, 1992.

a day. Young convinced the owner that Wendover Will would bring in more business than another dealer, and the sixty-four-foot-tall cowpoke has been hailing down gamblers from the highway ever since. A third colossus, Laughlin Lou, was competing for gamblers along the Colorado River in the southern tip of the state when we visited the Pioneer Hotel and Gambling hall in Laughlin.

But Wendover Will occupies a special place among Nevada's neon giants. Whereas Vegas Vic and Laughlin Lou are surrounded by the bright lights of many

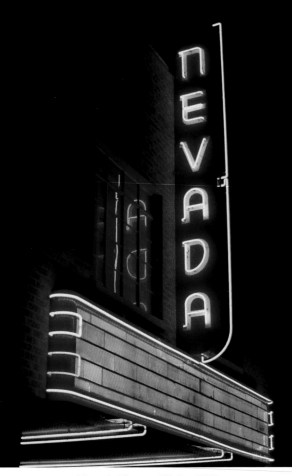

Nevada Theater, Wells, 1978.

other casinos, Will stood tall and alone for years against the deep Nevada sky, with no one and not much else sharing his call for attention except the desert stars. For travelers speeding down Interstate 80, Wendover Will emerged high on the horizon, a dapper old-time cowboy with his kerchief and six-gun, waving his enormous mechanical arm and pointing to the last gambling house before the Utah border. He's the stuff of a neon cowgirl's dream.

By the 2010, new casinos were competing for the Wendover gambling trade, some of them bursting with a neon interior décor to rival Will's brilliance. In the Montego Bay Resort, a rainbow riot of abstract neon swirls from the slot machines to the ceiling, looking like cascading confetti and ribbons—hula-hoops of neon.

Sometimes you need to understand the local codes to figure out what a neon sign really means. The red letters spelling *Donna's* against the Wells sky meant prostitution long after the original Donna left town. "There is no Donna," the doorkeeper at the establishment told us. "Donna used to have it.

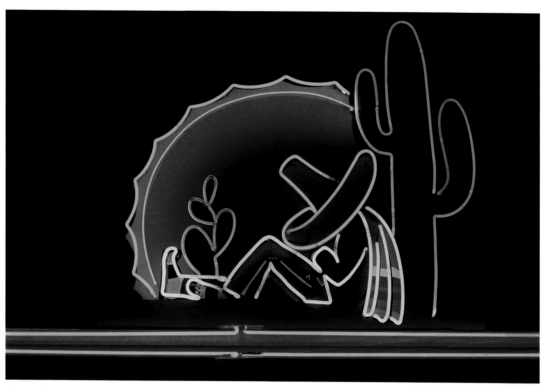

Cactus Pete, Jackpot, 1978.

She sold it. We keep the name for tradition." It's rare that a naive traveler pushes open the door at Donna's expecting a family-style roadhouse. "They either know what it is, or they don't care." In addition to the telltale red color of the sign, the location of Donna's—away from town and isolated from other businesses—provided a good indication of the nature of the business.

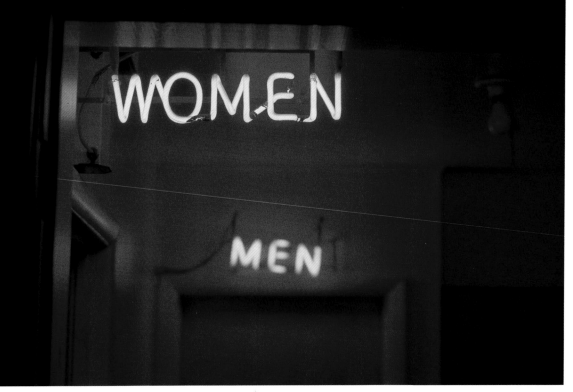

Interior bar signs, Austin, 1978.

Late one night in Wells, we were tired after a long day's drive. As we studied the map and the miles of empty desert between us and Jackpot, we decided to call ahead to Cactus Pete's casino before we added more miles to the day.

"Are there neon signs up there?" we asked.

"Partner Honey," Billie the bartender answered, "I wouldn't know the difference."

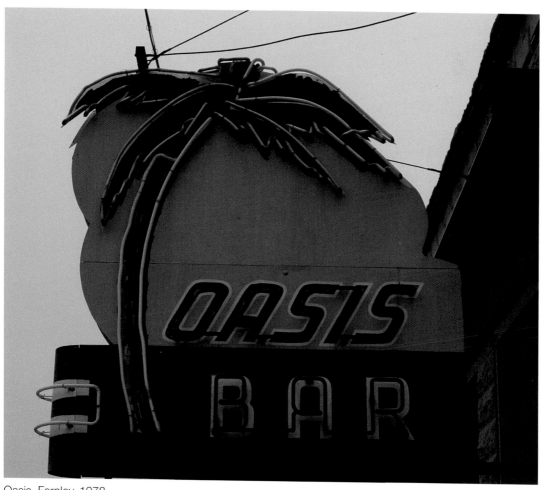

Oasis, Fernley, 1978.

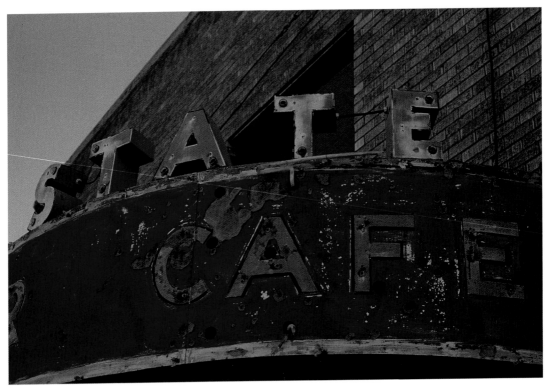

The Old State Diner, Carlin, 1978.

So we headed up to the Idaho line, a trip worth the miles of sagebrush and jackrabbits. Cactus Pete does not point or wave. He waits for customers, taking his endless full-color neon siesta, which was reward enough for us weary travelers.

Burning out, Winnemucca, 1992.

Light on the Loneliest Road in America

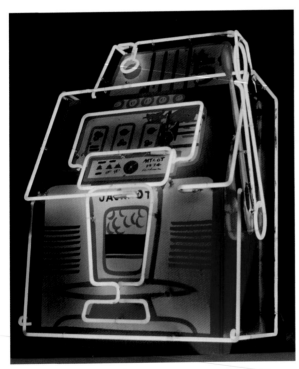

Hotel Nevada, Ely, 1978.

It was Life magazine that made U.S. 50 through Nevada infamous when it proclaimed the highway "the loneliest road in America." But *Life*'s reporters should have ventured through the doors and behind the neon. On another icy winter evening we pulled up in front of the Hotel Nevada in Ely and parked under the casino marquee's oversized model of an old-style slot machine, its contours brightly outlined with glowing neon tubing.

"The first thing I look for when I hit a town," one old Nevadan told us on the road, "is a neon sign. I know it's a place that's open where I can get a drink."

We pushed open the door of the Bank Club as much to get out of the cold as to find refreshment. We were waiting for the sun to go down.

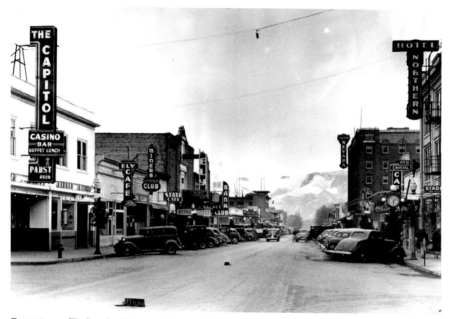
Downtown Ely lined with neon signs, ca. 1939. (Courtesy of Nevada Historical Society)

A fellow named Homer won a hundred-dollar jackpot as we sat down at the bar, and he immediately bought drinks for the house. Minutes later he won another, and with a hoot and a holler, he bought the bar two more rounds. At the same time, on the loud television, Dallas was winning a football game, and the bar's two pet fire eels, Morris and Madeline, passed the time languidly in their tank. One of them massaged itself against the aquarium oxygen bubbles, while the other took a nap on the bottom.

Soon Homer was no longer winning at his slot machine, and we ordered a couple of bowls of Mark's homemade chili, advertised as winning the

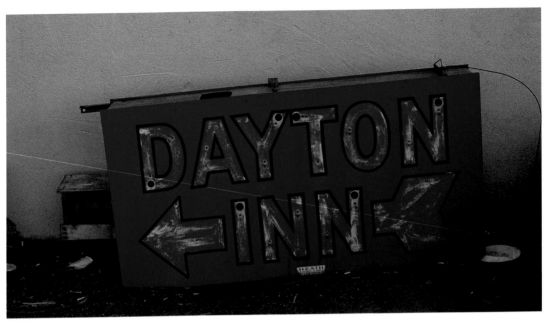

No more room at the Inn, Dayton, 1992.

second-runner-up prize at a Texas chili cook-off. Just as we finished our dinner, Homer, right on schedule, hit another jackpot and bought another round. Here's to you, Homer.

By the time it got dark and we went back outside to capture the Hotel Nevada's big slot machine on film, we knew that there was nothing lonely about Ely.

Our goal as we collected our neon was to show the signs from the perspective of passersby but at the same time to isolate the neon from any adjacent images so that each photograph captured the pure essence of a sign. We sought

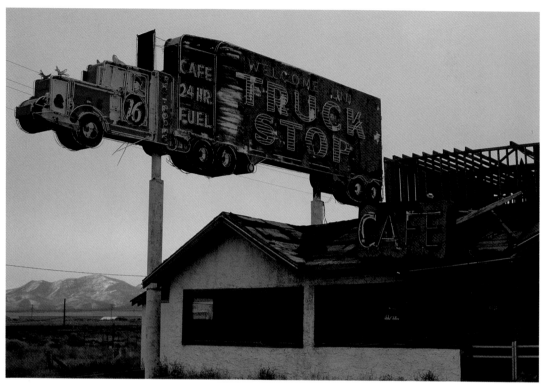
Bypassed truck stop, Winnemucca, 1978.

to keep street lights out of our frames and to choose angles carefully so that adjacent street scenes did not create unwanted distortion and distraction. We often found the best location for taking pictures by parking our Volkswagen in front of the neon and climbing up on the camper to grab the shot. From the roof of the VW we secured the old blue Bank Club slot machine, an old sign that shined on in the 1990s.

The new Joe's sign presiding over the entrance to the Hawthorne Bar, the defunct sign languishes in the alley over the back door, Hawthorne, 2010.

Other forties- and fifties-era neon lived on in front of many of Ely's old motels. There was a scattering of neon in Eureka and Austin, but Fallon was a Highway 50 neon bonanza. Although the old movie theater marquee no longer lit up, the Lariat Motel's hardy cowboy still spent every night casting his lasso toward passing cars. By 2010, he too was a motel memory. There were two classic old neon

signs offering directions to the Western Motel. In the heart of downtown Fallon, the E.H. Hush Insurance Agency continued to advertise its services with old neon script that reminded residents that Hush had been selling them insurance "Since 1919."

A fast hour south, on our second trip, we found the Yerington theater neon was burned out. The owners wanted to light it again, but they simply could not justify the expense. And by 2010, not just the sign, but the theater itself, was long gone. Just a few blocks north on the highway back to Fallon the I.H. Hunt feed company proudly spelled out its name and business in traditional neon.

After dinner at Dini's Lucky Club and Casino, we pointed the rented car south on our third trip, with Hawthorne as the night's destination. Just past Walker Lake, a full moon lighting our path, we rounded the last bend before that shopworn crossroads on Highway 95, and were surprised to be greeted at its limits by a bright red beacon spelling out H-A-W-T-H-O-R-N-E.

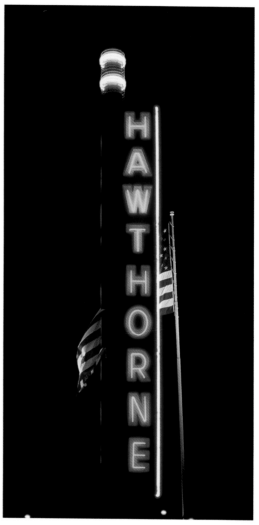

Hawthorne, "America's Patriotic Home," 2010.

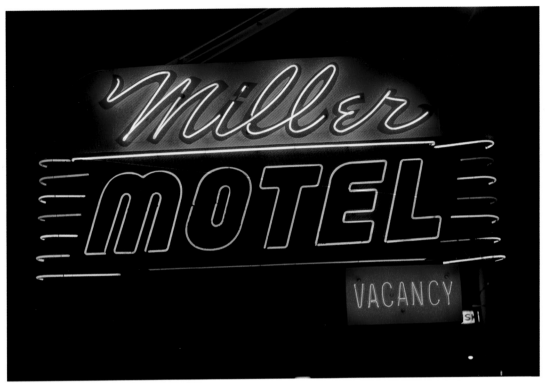

The Miller Motel, Ely, 1978.

Former Mineral County sheriff Rocky McKellip told us he was the law in Hawthorne in the early 1990s when he joined his neighbors to watch a wrecking crew demolish the Hawthorne Club. "The whole town turned out," he told us. The sign reminded the sheriff of the Reno arch spelling out "The Biggest Little City in the World."

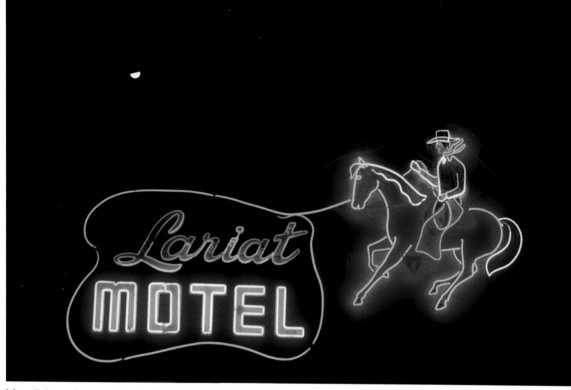

Moonlight and neon at the Lariat Motel, Fallon, 1978.

"I'm standing there, looking at the Hawthorne sign, and I thought, we could have one too. Signs like that make people stop." Sheriff McKellip managed to rescue the sign and rallied the crowd to preserve the old landmark that had been burning on the desert since the 1940s, although when he first suggested saving it, "They all thought it was nuts." Money for restoration came from the county coffers. "Arlo Funk, he's the one who made sure we got the money," McKellip was

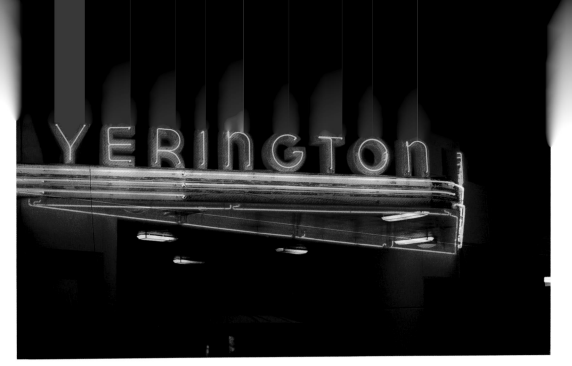

The Yerington theater, 1978.

quick to give former county commissioner Funk the credit. "Did you notice the little space ship thing at the top?" he asked. We did—it's dazzling.

Further west in Dayton, one of Nevada's oldest settlements, the derelict Dayton Inn sign, its glass long gone, leaned against an outside wall of the old bar. When the state widened Highway 50 to four lanes through Dayton, the Dayton Inn learned that its sign hung over state property. Instead of repairing and moving the old marker, the owners just hauled it down and forgot about it.

Chapter Seven

New Flare in the South

A Nevada neon hunt is a nighttime activity. The desert night sky and two-lane roads, punctuated with occasional neon signs, create a mood unique to Nevada. Often the only lights for hours are the constellations and a few passing cars—until far off in the distance there is an electric flicker that suggests some form of civilization on the horizon. South from Las Vegas, for example, in 1992 there seemed to be just nothing left when, at Indian Springs, a soft blue glow on the west side of the highway announced through the dark in sympathetic letters "Oasis."

When U.S. 95 almost runs out of Nevada, Laughlin suddenly appears on a side road in the Colorado River Valley, in a startling blaze of electricity. Laughlin exists for gambling. Casinos, one after another, dominate the main street and the riverbank. We scoured the new town, looking for extraordinary samples of neon. Although there were tubes all over, running up and down the sides of buildings, coexisting with flashing incandescent bulbs in gaudy signs, most of this new neon looked mundane and perfunctory to us. Besides Laughlin Lou and the Hilton's flamingos, not much was eye-catching. There were few pictorials, little of the soft glowing that makes the neon seem to come away from a sign and create an atmosphere that is separate from any advertising message.

Neon lights start to come alive at twilight; the glows that emerge create a nightlife of their own. In a setting like Laughlin—so lit up with a variety of ambient light in the middle of the night—the neon shining during lit-up nights

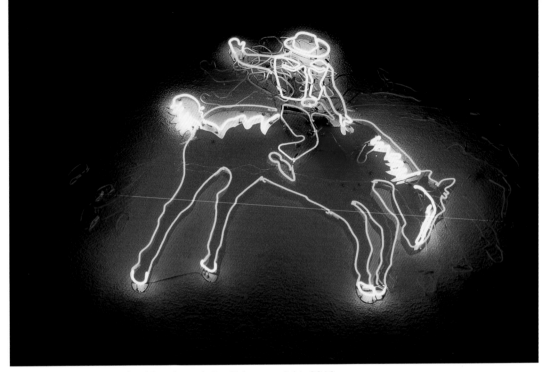

Saddle West's cowboy, bucking through the Pahrump night, 2010.

is much like neon left on in daylight hours. The magic struggles but cannot perform at its best. Las Vegas was a different story. Because there was such a massive onslaught of neon along the Las Vegas Strip, the monster neon signs themselves were captivating despite the lit-up scene. Their sheer size and awesome complexity dwarfed any competition for attention.

Beatty straddles the highway a couple of hours' drive north of Las Vegas. It was cold and quiet as we drove along its few commercial streets looking for signs

The deteriorating sign of the 49er Cocktails in Searchlight, 1992.

that glowed. The Exchange Club flashed an arrow around the offers of "restaurant" and "casino." Inside, the regulars exchanged stories, playing a friendly poker game. Next door, a series of hot-white neon high heels dotted a place just called The Bar.

After we had collected all the signs in Beatty and made an eerie nighttime tour of the neighboring ghost town Rhyolite, it was still early. Instead of speeding back to Las Vegas on the dark two-lane highway, we checked into the Burro Inn. The casino was scattered with Beatty locals. A few pulled slot machine handles under a Quartermania neon sign. New signs in script inside casinos all

The rainbow flamingos at the Laughlin Hilton, 1992.

around the state, like Quartermania, reflect neon's successful renaissance. Other customers nursed their usual drinks at the bar. And a few, like us, danced to familiar country and western tunes struck up by a fine cowboy duo. By the end of the night, the bartender forgot we were strangers and smiled at us.

We stopped into the Beatty Museum and Historical Society on our third trip, where its president, Amina Anderson, the enthusiastic descendent of one of the museum's founders, had news for us. The Oregon Motel is not just out of business, the building has been demolished along with its basic roadside neon

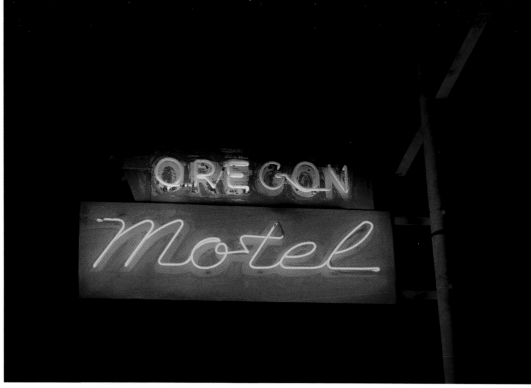

The unlikely named Oregon Motel in Beatty, 1992.

sign. She pulled out a 1960 Beatty High School yearbook and showed us the page where the Oregon Motel advertised its "clean and modern rooms."

Last stop that evening was Pahrump, and a surprising visit to the Chicken Ranch. Instead of the usual dilapidated trailers behind chain link fencing that mark so many Nevada brothels, the Chicken Ranch looked like a lovely suburban home with charming dormered windows and inviting lights. Out front was a neon girl's leg, high kicking, of course.

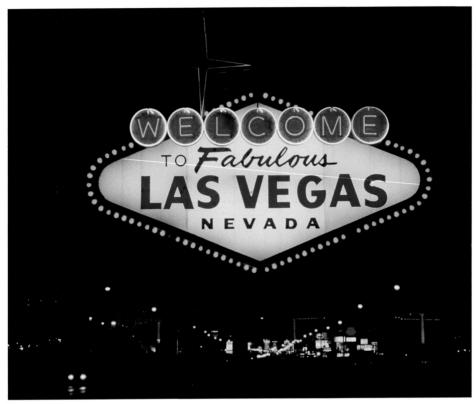

Welcome to Fabulous Las Vegas, Nevada, 1992.

In what passes as Pahrump's downtown—just sprawl along the highway—the Saddle West casino's cowboy, dressed up in white, green, yellow, red, and purple, stays on his mount all night long. The horse bucks him in four sequential jumps. Periodically it tires and takes a rest, before continuing its ride through the night.

Las Vegas

Nowhere in the world was there such an intense assault of neon as there was along the Las Vegas Strip as late as the early seventies. The casinos along with other only-in-Nevada businesses vied with each other to create the most exciting crowd-pleasers, from the Cupid Wedding Chapel and its bright pink heart

The iconic roadside sign replicated at McCarran Airport, 2010.

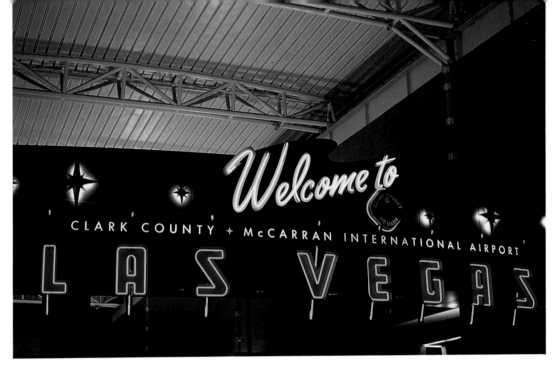

The first neon off the plane, Las Vegas, 2010.

to the delicate flamingos at the Hilton. The lights in Glitter Gulch and along the Strip were alive, not just with the natural movement of the electrically charged gases, but with animated fantasies. The outlines of plants, animals, planets, and simply abstract designs flashed and constantly changed perspective while bursts of color instantly transformed the pictures into rainbow rushes of intense lights.

The statistics associated with these walls of neon were as amazing as the images the lights cast on the casino walls. The gigantic neon pictures demanded a construction investment of some million mid-twentieth century dollars. The

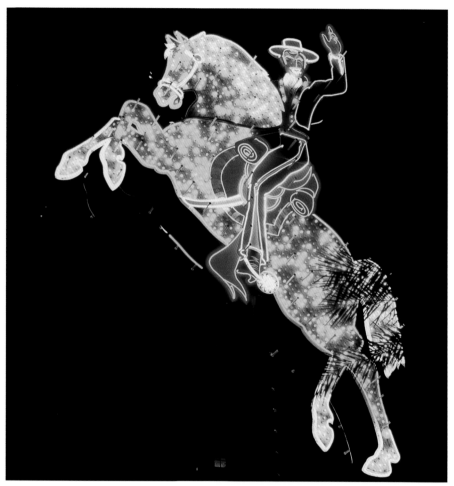

Reconstructed horse and rider, Fremont Street, Las Vegas, 2010.

Nature and neon meet at the Sulinda Motel, Las Vegas, 1992.

electric bills for lighting the literally miles of neon tubing that lined the Strip in those days hovered around five thousand dollars a month for each extravaganza.

The sign companies at work on major projects in Las Vegas—YESCO, Federal, Ad-Art, and Health—found spectacle-dreaming artists to design the outrageous facades of moving light that catered to their clients' whimsical desires. Initial inspiration for the flash that lined the Las Vegas Strip came from the dense neon that developed in downtown Las Vegas in Glitter Gulch, along the few blocks directly south of the old Union Pacific railroad station. The casinos there took advantage of the cheap electricity available from the Boulder Dam project and, by the fifties, filled Fremont Street with artificial light. Although most of the action eventually moved to the Strip, Fremont Street remained lit up, featuring a fading cowgirl kicking her long legs

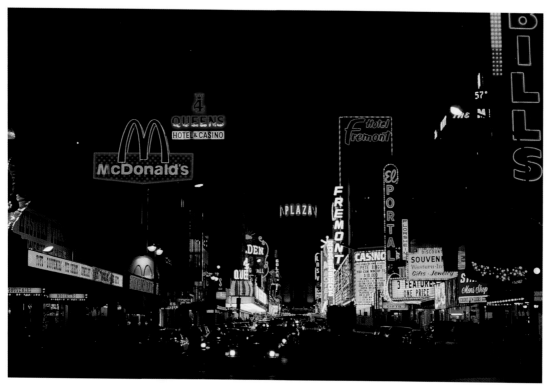

Fremont Street, Las Vegas, 1978.

at Vegas Vic, across the street, as she lured men in off the sidewalk to see the girls dancing topless at her club.

We found that kicking neon Vegas cowgirl and her boyfriend Vegas Vic on our third trip, but they had become museum pieces. Neon preservationists kept them and a select group of their companions from ending their days dark and discarded. Instead, restored, they flashed prominently at each other from

The swirls of Vegas World on the Las Vegas Strip, 1992.

pedestals built for them in the middle of the street. Placards were installed to inform curious passersby about their role in Las Vegas's history. The Hacienda Horse and Rider is a prime example. He and his mount were rescued from the YESCO graveyard. We saw the two of them there in the early 1990s: static, unlit, and forlorn, amongst the litter of unused signs sent back to their maker. The two were first installed at the old Hacienda Hotel in 1967—relatively late in neon history, and abandoned not too many years later. But Las Vegas architect Brad

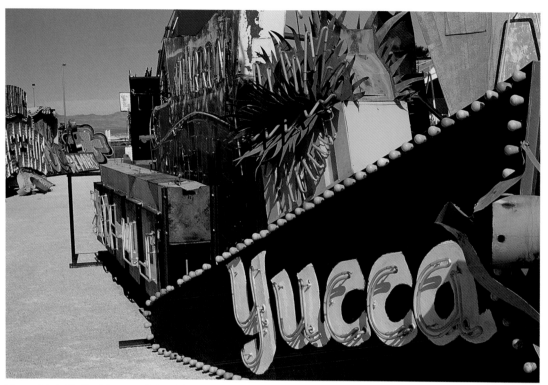

Yucca Motel in the Boneyard, Las Vegas, 2010.

Friedmutter took pity on the old cowboy and financed his reconstruction. The Hacienda Horse and Rider ride again over the intersection of Fremont Street and Las Vegas Boulevard.

Just a few blocks south of all that glitter, shopworn Fremont Street becomes the Boulder Highway, and the casino neon softened to the gentler radiance of the neon store and motel signs dating from the thirties, forties, and fifties. But by

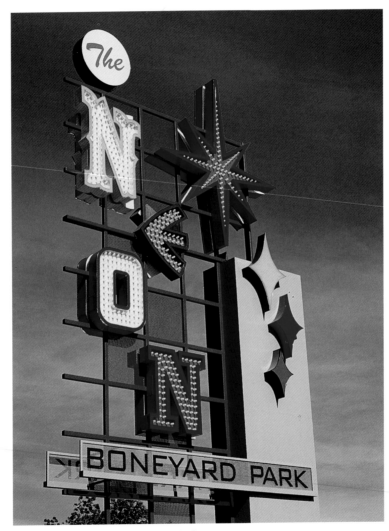

The Boneyard Sign, Las Vegas, 2010.

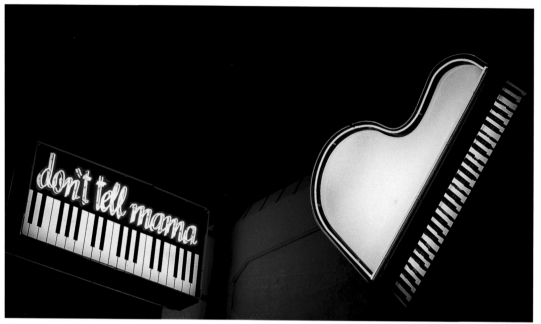

Piano bar, Las Vegas, 2010.

2010, most of those businesses were defunct or depressed and their signs either a memory or in decay.

The elegant suggestion of finely dressed ladies and gentlemen ready for a night on the town vanished from the Society Cleaners sign during the eighties. The clerk at Society Cleaners was nostalgic about his store's sign, some parts of it dim, others no longer lit at all. "It used to be on all the time," he told us, "but then it was hit by a rock, and it's too expensive to repair. The neighborhood has deteriorated to such an extent that it has become sport for people to throw rocks

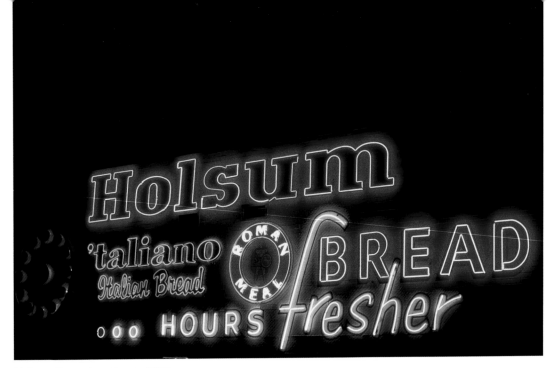

Holsum Neon, Las Vegas, 2010.

late at night." Years later the sign was removed from the dicey neighborhood and restored for posterity.

Against the odds of a fickle tourist trade that had moved on to the casino resort hotels, one after another the Boulder Highway hotels continued to parade their romantic names and symbols in neon on through the 1990s: the Comet Motel, the Sky Rancho, the Blackjack, the Par-A-Dice, the Desert Hills, the Safari, the Vagabond, the Bonanza, the Star View, and the (triple X-rated) Desert Moon with its neon script casting a delicate green on a likeness of the moon.

Deferred maintenance, vandalism, and disuse all take their toll on the motel signs. As was the case on the unfortunate Mapes cowboys in Reno, pigeons frolicked on what was left of the Skyway Drive-in Theatre sign along the Boulder Highway strip. Nearby, the sequential-lighting switch was broken back in the early 1990s at the Valley Motel. The poor fellow trying to direct drivers into the old motor court with his animated thumb looked as if he had three arms and three thumbs—all three panels of the series were lit up all the time.

Although a well-built neon sign can continue to function for over a generation, the harsh Nevada weather takes a toll, so most signs require some sort

The swatch panel at Young Electric Sign Company, Las Vegas, 1992.

of periodic servicing to keep functioning properly. The Young Electric Sign Company instituted its neon patrol to deal with the maintenance problems. With contracts to keep most of the Las Vegas Strip bright and flashing, YESCO sent inspectors out every weekday night looking for damage to repair. Ice and

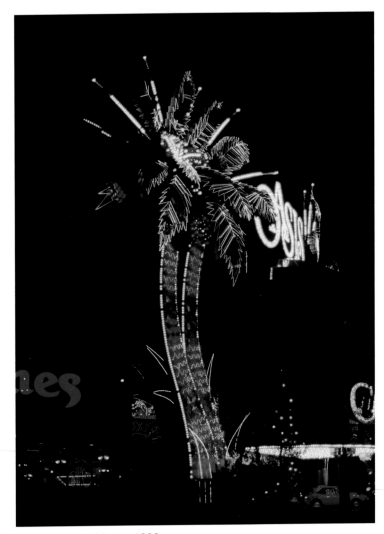

Neon palm, Las Vegas, 1992.

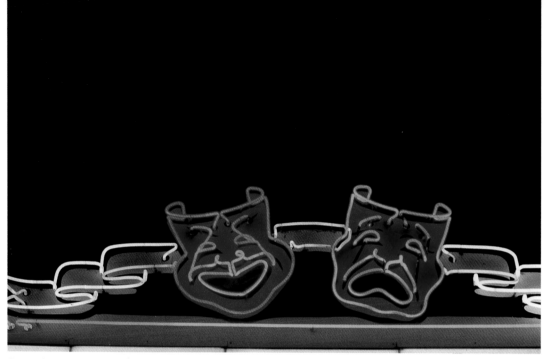

Comedy and tragedy at the El Cortez Hotel (Fremont Street), Las Vegas, 1992.

heavy rain can cause tubes to break, landing pigeons can cause the electric signs to short (and kill the birds), and plenty of neon—like the Society Cleaners sign— succumbed to direct hits from rocks and bottles.

"I wish I were back in my old Nevada, standing in the ladies room line at the Stardust Camperland with all those women in their pink hair curlers," Sheila reminisced in 2010 as we fought through the throngs on the Strip for a look at the Bellagio fountain and its ballet of water dancing to Andrea Bocelli and Sarah Brightman singing their hit "Time to Say Goodbye." We were melancholy for the days before faux volcanoes and fake pirate battles dominated the Strip. Back

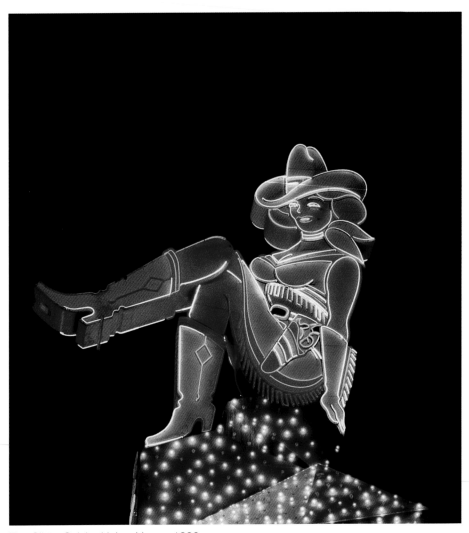

The Glitter Gulch girl, Las Vegas, 1992.

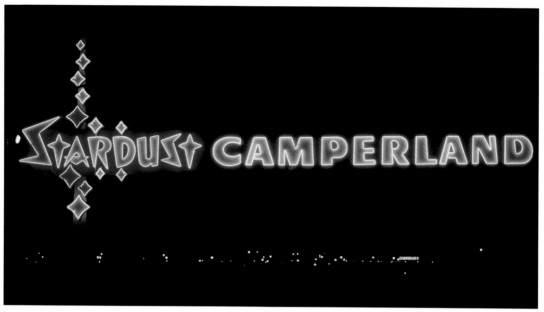

Stardust Camperland on Las Vegas Boulevard, 1978.

in the mid-1970s we parked our old Volkswagen bus overnight at Camperland, behind the campground's blue-and-pink neon marquee. A burst of neon starlight surrounded the Googie-style typeface spelling out "Stardust."

We found the old Stardust sign across the city at the new Neon Museum Boneyard. There, just a few blocks east of Fremont Street, dedicated neon aficionados collected the discarded signs from the YESCO lot and in the mid-1990s began a concerted effort to salvage what neon they could before it was lost forever to wrecking crews or the desert climate. We toured the outdoor Boneyard with the museum's operations manager Danielle Kelley, who is like a Bellagio

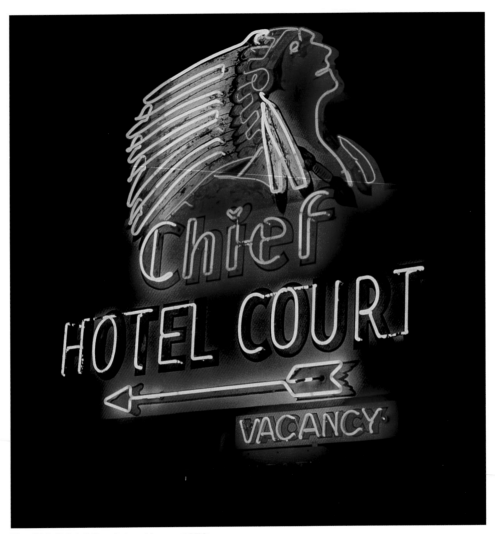

The Chief Hotel Court, Las Vegas, 1978.

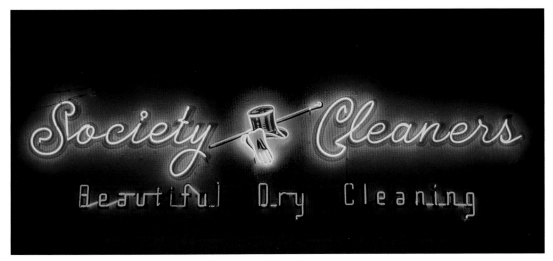

Society Dry Cleaners, Las Vegas, 1978.

fountain of neon knowledge and enthusiasm. She shares our nostalgia for the old Stardust sign.

"If I see the shape of the Stardust I know not only am I talking about Las Vegas," she exudes, "but about the typeface itself, which was invented here. Now it is not just the Stardust atomic typeface, it is the typeface that is used to evoke the atomic age. I believe that these signs as icons are deeply embedded in the cultural subconscious on a global level."

Kelley, too, remembers the Stardust when it lit up the Strip. "It seems old," she suggests, "but it's not old. It's thirty years ago. This is history that we experienced. It's a testament to the acceleration of time, the experience of time." She points to a pile of metal and glass.

"You're looking at it," she says with pride, "the Stardust sign."

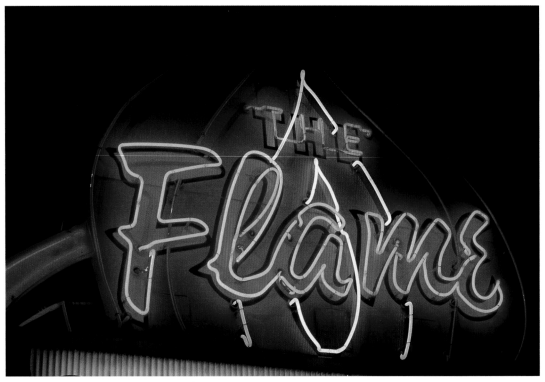

Flaming neon, preserved on Fremont Street, Las Vegas, 2010.

We recognize the starbursts. The sign looks immense, lying in pieces on the Boneyard desert floor.

"These signs wear their history and they wear them very grandly," Danielle Kelley looks at the discards with great respect. "We really honor that."

The night before we had escaped the Strip after taking pictures of two new pure neon signs adorning Las Vegas Boulevard: tequila and chocolate,

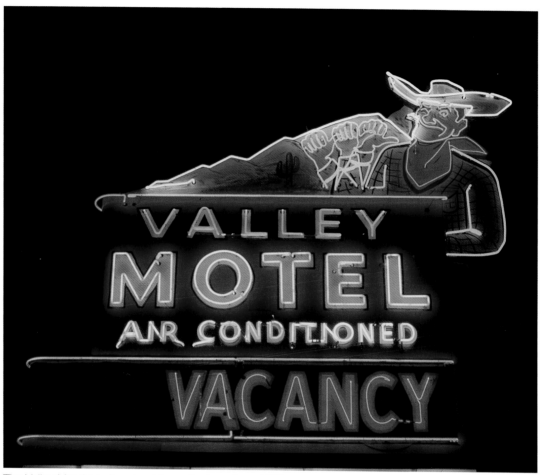

The Valley Motel cowboy, Las Vegas, broken since 1978.

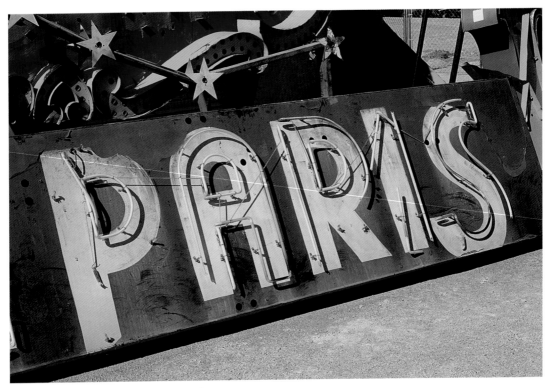

Paris in the Boneyard, Las Vegas, 2010.

Margaritaville and Ghirardelli. We hit Fremont Street seeking more neon and encountered a bar with two unlit signs that looked promising just as we were ready for a margarita ourselves. Don't Tell Mama was the name of the newly opened piano bar; they lit the sign early especially for us and mixed us two stiff drinks as the pianist opened the evening with a rousing rendition of "Bridge Over Troubled Water."

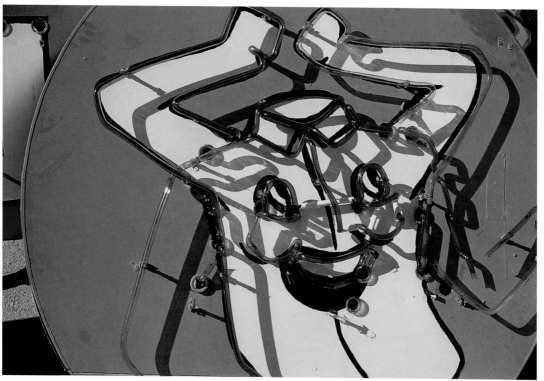

Laundry pictorial, in the Boneyard, Las Vegas, 2010.

We wandered up Fremont, admiring the handful of restored signs on display that were competing with Vaudeville acts on the promenade, including the Chief Hotel Court, a majestic image we last saw in the late 1970s when he still presided over the motel. After another Don't Tell Mama margarita, we waited in a ludicrously long line to check into our bargain Imperial Palace room back on the Strip. "We upgraded you," announced the clerk with a wide smile, "to a

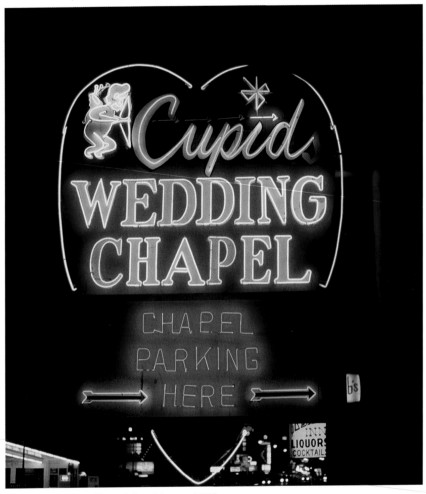

Cupid's Wedding Chapel, Las Vegas, 1978.

penthouse." As is neon, suite number 1935 is a remnant of faded glitz and glory, with a bar in the living room, a mirrored dining room featuring a glass-topped table, and neo-Ionic columns rising from the Jacuzzi in the bedroom. We drifted off to sleep looking out at the endless Nevada desert under the hotel's pseudo-pagoda rooftop—an architectural flourish lit with a strip of soft blue neon.

The Tube-Bending Craft

"Anything you can write, we can make." Neon sign maker Bob Poalucci was not boasting, just explaining how completely he and his colleagues could turn glass tubes into the letters and pictures that come alive as neon signs. The process appears deceptively simple, although tube benders, as the craftsmen call themselves, agree it takes years to master. The method of creating a

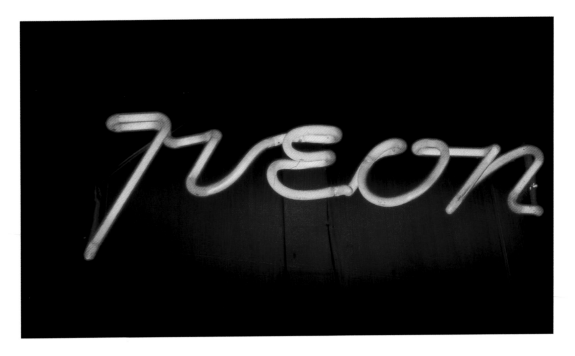

neon sign has changed little from the days when neon first became an advertising tool.

We were watching Poalucci demonstrate his tube-bending techniques in the YESCO Las Vegas shop. He held a straight piece of plain glass tubing over a gas flame, turning it as he heated one spot. "The heating is to get the glass to a certain consistency," he told us. "When it starts to give, you bring it over to the pattern and start to form it." Paper patterns were on his workbench, the words and designs in reverse, drawn to the actual size of the sign being fabricated.

Each letter in a complex sign is formed individually, and then the words are welded together with a hand torch, the molten glass readily fusing one letter to another. To shape the glass tube from hot glass, Poalucci put a cork in one end of the glass tube

Cactus sculpture from the Yucca Motel, in the Boneyard, 2010.

and attached a rubber hose to the other end. He held the rubber hose in his

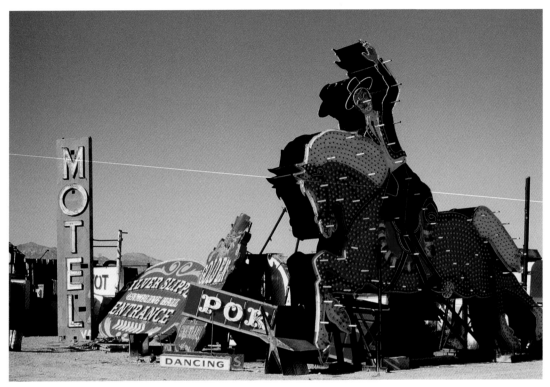

Tom Romeo's neon graveyard, 1992.

mouth and periodically blew into it gently. "While you heat it you have to blow to keep the tube open." He kept the diameter of the tube at a constant size while he bent the softened glass to the shape of the letter he was fabricating.

Once the tubes are bent to create the words and pictures for a sign, a pump is used to remove the ambient air and impurities from the glass. The vacuum

in the tubes is replaced with gas; then the tubes are fitted with electrodes and sealed. Bombarding the neon or argon gases in the sealed tubes with electricity makes the gases glow. Specially designed neon-sign transformers send about 15,000 volts of electricity through the electrodes. That charge ionizes the gas, creating the characteristic moving light of the neon sign.

Although other inert gases can be charged with electricity to generate light, neon and argon, because they are more common and less expensive than others, are the two used for commercial sign work. Neon gas glows red. Argon gives off blue light. When mercury is added to a tube filled with argon, the glow turns turquoise. Most of the rest of the rainbow of colors that fill the Nevada sky are created by putting those two gases, sometimes with added mercury, into colored glass tubes.

With the renaissance of neon, there continued to be a shortage of trained tube benders. Although there are schools that teach neon sign making, there are few graduates who choose a sign-making career. Most neon craftsmen, and they are mostly men, were closing in on retirement age when we met with Poalucci in 1992. "Learn this," we heard more than once, "and you have a job for life."

"To me it's history. It's part of Vegas. It's part of Nevada," Tom Romeo said as he was walking with us outside the YESCO shop, through a yard littered with what at first glance appeared to be just piles of discarded and broken neon signs. One of YESCO's salesmen, Romeo had been assigned custody of what the company called its neon graveyard. "It used to be just old, broken-down signs to me," he told us as he showed off what amounted to a history of Nevada electric signs. "The company stuck me with this job, but now I realize that you can't find this anywhere else in the world."

Romeo grew to appreciate his new charges and arranged the old carcasses so he could run power to them and light them up. He cut a path through his electric graveyard wide enough for a car, and he rented the whole scene out to movie companies looking for a flashy setting.

The old 5th Street Liquors sign was in the graveyard then, lovingly restored by YESCO's craftsmen, and waiting in crates to be shipped off to an exhibit as a showpiece of its era. Signs from the Golden Nugget and the Silver Slipper lay on the ground, candidates for cannibalization or rebuilding for new clients. The lamp from the old Aladdin sign—and longtime Las Vegas landmark—remained dormant in the yard.

That history Tom Romeo saw reflected in discarded neon is not only Nevada's, it's also the personal history of sign owners like the Patel family, whose patriarch Bhagu Patel emigrated from India to America and—like so many Nevadans— moved to the Silver State seeking a good life for himself and his family. "He landed in Las Vegas," his son Vitas Patel told us, "and, with whatever money he was able to muster and save, he bought this little motel." The little motel was the Yucca, a typical American roadside inn, sporting a flashy neon welcome with its neon name encased in an arrow beckoning to motorists and topped with a brilliant rendition of a yucca cactus looking alive in sparkling green and white.

In 2009, Bhagu Patel and his wife Manjula closed the business, after it provided for their sons' university educations and the family's financial security. The motel rooms were razed, but the Yucca sign was spared—not only for its value as a cultural artifact. "Our biggest legacy for him," Vitas Patel said after his father's retirement, "was that sign, which was a landmark for him." The family donated the sign to the Neon Museum, where it presides in the Boneyard, stoically greeting new generations to Las Vegas. "He's just happy to see that there was a piece of him left alive in Vegas."

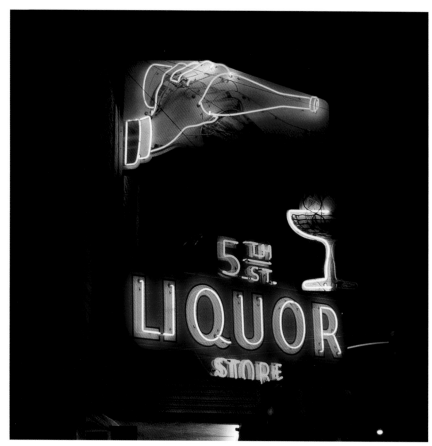

The 5th Street Liquor Store sign, captured in 1978.

Before we said good-bye, Patel mused about the glowing cactus that illuminated his childhood and came to represent his family's success. "My father never changed that sign. You're talking about a guy who came from a Third World country and I think he identified so much with that sign. It defined him and where he laid his hat. He didn't want to change that thing, modernize it, even when we had the money to do it." When the family decided to give the Yucca neon to the museum, "he was so excited seeing his name next to that sign."

That preserved neon represents the fulfillment of an American dream.

The Future for Neon in Nevada

We concluded our second neon search through Nevada pleased to learn that, at least for then, enough of the classic signs we so enjoy were still operating in their proper places and were not in danger of being exiled to the YESCO graveyard—or suffering a worse fate. On our third journey, the neon picture became even brighter. Not that the visual pleasure we derive from neon is universally shared. There still are plenty of travelers who speed through Nevada convinced that Wendover Will and all his electric relatives are tasteless and gaudy intrusions on the desert landscape, not luscious valuable public art expressing our commercial popular culture. In the art world, however, the picture has changed. The space-age Yucca Motel sign was saved once the Patels realized its familial value at the same time that art curators sought its preservation. The sign's new home is the Neon Museum in Las Vegas; the museum is a civic statement that Nevada cherishes its neon heritage. Sign companies and neon aficionados work together, on alert for neon treasures about to be destroyed. They rush to demolition sites to negotiate deals to save signs. And a next generation of tube benders creates new works designed not only for roadside signage but also as gallery art.

A soaring new neon pavilion beckons visitors to the museum. Bright letters spell out that magical word *neon.* As we looked at the huge sign, the museum's Danielle Kelley provided the historical perspective for the typefaces, explaining the heritage of each letter. "The Golden Nugget is the N at the top. You've got the E from Caesar's. Binion's Horseshoe is the O. And the N is from the Desert Inn."

The fantasies of neon designers and craftsmen, Las Vegas, 1992.

Around the world, there may be no neon to match Nevada's. This is not just a matter of quantity and quality, but of culture and landscape. The combination of Wild West mythology and the remaining untamed pitch-black Nevada nighttime landscape with real cowboys and real gambling, makes Nevada a unique and

appropriate canvas for neon art. Modern Nevada began with a nonstop desire for riches. It continues on for many as a state of dreams often vividly expressed through exploding neon.

Most commercial neon pieces are unsigned works, the designers and craftsmen remain anonymous to their public. The stories behind the signs usually remain behind the scenes, too. We know who Shorty is now, and why the pig flies in Winnemucca, how the Oregon Motel sign disappeared, and the Hawthorne Club sign was saved. But there are other legends, and some romance, behind most of these roadside renderings. Perhaps our redhead in the martini glass in Elko was once somebody's dream girl. The mystery adds to the magic and can help a pensive traveler pass the miles.

Every sign was once somebody's brand-new baby. People stood around with their friends one special night, waiting for the sun to go down, for it to get dark enough to turn on their new light. It is this vespertine nature of neon that is most alluring. The neon glows like the stars, waits until night to really sparkle. Our search for the signs was like looking for constellations. As evening's darkness increased, we picked out those signs that most intrigued us, aware of some of their stories, while others' we could only imagine.

Overall, we found even more of a renewed appreciation for the historical value of Nevada's neon. Communities and their businesses are not so quick as they once were to discard the old signs. There is a growing appreciation for commercial neon as intrinsically intriguing and not just among art historians and popular culture preservationists. The medium no longer is rejected as conveying a message of blight; flowing neon script directs shoppers to elegant locales. Perhaps most important to the future of Nevada's neon is both the renewed realization by store owners that neon signs continue to attract attention that

brings in customers and the public's appreciation of neon: The Neon Museum in Las Vegas is booked months in advance by visitors lured by the intrigue of its Boneyard for events from movie chase scenes to marriage vows.

The bright, moving, colorful shapes and symbols flashing along the roadways do their job and communicate clearly. Whether a waving giant cowboy, an undulating casino wall alive with red and orange luminous stripes, and a flying blue pig are considered art is—as always—in the eye of the beholder, but there is no question these neon creations command attention. In our society, that alone guarantees the survival of the genre.

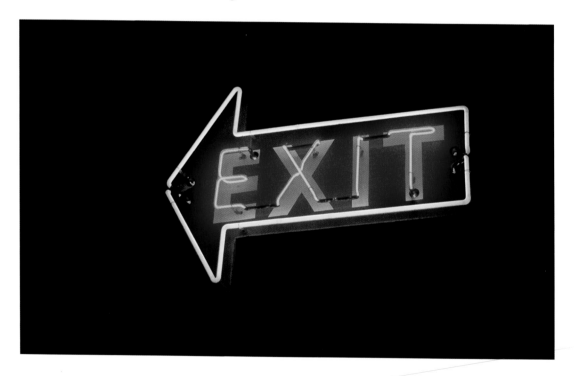

Acknowledgments

Without the artists and craftsmen who created the magnificent neon documented here, there could be no *Neon Nevada,* and we thank them for the pleasure we've derived from their work.

Phillip Earl, curator of the Nevada Historical Society, cordially opened the society's massive files to us and helped us sort through them. Chelsea Miller Goin graciously shared the research she compiled for the Nevada Museum of Art and the Nevada Historical Society during a study funded by the Nevada Division of Historic Preservation and Archaeology and the National Park Service. Ellen Muth, the research librarian at the Elko Library, went out of her way to guide us to needed primary sources. Friend and photographer Ira Kahn immediately appreciated the project and he offered valuable technical advice. Robert Winkelman and his Evergreen Film Service laboratory in Eugene, Oregon, skillfully transferred our 35 millimeter film transparencies to the digital world.

We embrace Eva Laufer for her encouragement, Talmage and Amber Morris for their enthusiasm, and Michael Laufer for his help during our treks across the neon desert.

We wish to thank Tom Radko who, as director of the University of Nevada Press, published an earlier edition of our neon studies. At a festive New York City luncheon, our colleagues at Globe Pequot Press, Holly Rubino and Georgiana Goodwin, shared our vision for completing our neon project. Thanks to them, our editor Meredith Rufino, and the entire supportive GPP staff for their creative work producing this book.

And a clink of the neon martini glasses to Silver City, where it all began.

Select Bibliography

The *Neon News* was a quarterly published by Val Crawford and Ted Pirsig. Its contents ranged from specific technical information for neon construction, to advice about the health hazards associated with the craft, to interviews with neon artists. It ceased publication in 1995 but some of its content is available online.

Tom Wolfe's *Kandy-Kolored Tangerine-Flake Streamline Baby* (Farrar, Straus & Giroux, 1965) helped set the stage for appreciation of Las Vegas neon with an account of how signs on the Strip influence American architecture.

Let There Be Neon, by Rudi Stern, offers a broad overview of neon in general (first published by Abrams in 1979, it was revised and reissued in 1988 under the title *The New Let There Be Neon*).

Neon Nights is the catalog by Peter Bandurraga published in 1990 by the Nevada Historical Society in conjunction with an exhibition at the society's Reno headquarters. The catalog is out of print but may be viewed at the society library.

Neon in Nevada: A Survey of Contemporary and Historic Neon Signs in Nevada is a 1986 report by Chelsea Miller prepared for the Nevada Division of Historic Preservation and Archaeology.

About the Authors

Sheila Swan Laufer learned photography as an assistant in her father's portrait studio. She joined the Nevada Craft Guild shortly after it was founded and there began her study of Nevada's relationship with neon. Memoirs of her experiences on the road are collected in her book *Safety and Security for Women Who Travel*. She served as the associate producer and editor of the award-winning documentary film "Exodus to Berlin" and her current photography is focused on Polaroid transfer and emulsion prints.

Peter Laufer is the author of more than a dozen books that deal with social and political issues, including the widely praised *The Dangerous World of Butterflies* and *Forbidden Creatures,* both published by Lyons Press. He is the James Wallace Chair in Journalism at the University of Oregon School of Journalism and Communication. More about his books, documentary films, and broadcasts, which have won the George Polk, Robert F. Kennedy, Edward R. Murrow, and other awards, can be found at http://peterlaufer.com.